Frank Kelly Freas
AS HE SEES IT

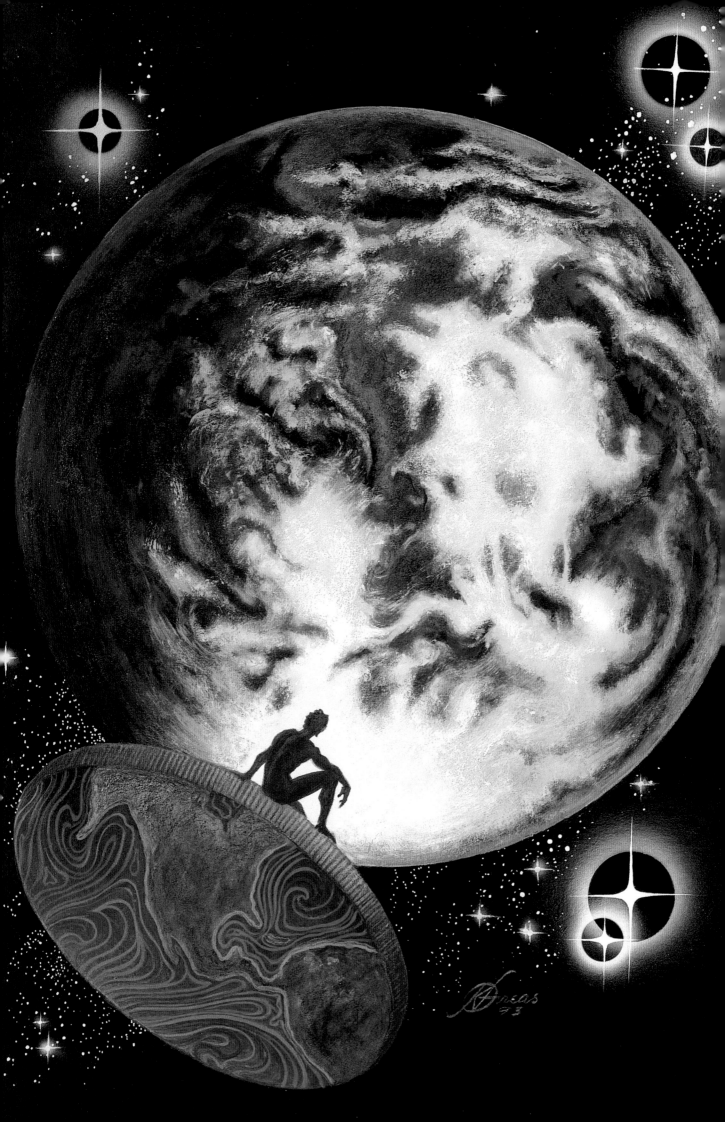

Frank Kelly Freas
AS HE SEES IT

Text by Frank Kelly Freas and
Laura Brodian Freas

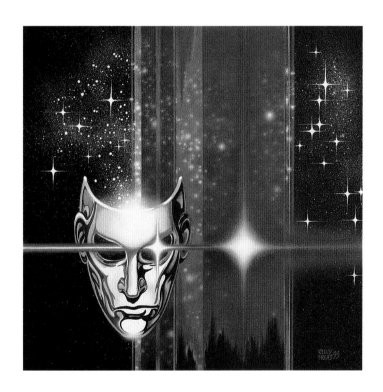

Preceding page left:

Thinking Beyond the Edge

Acrylics: 15in x 20in (38cm x 51cm)

Sitting at the edge of a flat earth, man visualizes a spherical one . . . Well, maybe he did. Most of us probably wouldn't have been able to make that mental/emotional jump, but obviously someone, somewhere, at some time did.

Cover, anthology edited by Aidan Kelly, Agamemnon Press, 1993

Preceding page right:

Transition

Acrylics: 30in x 30in (76cm x 76cm)

For some forgotten reason I did this one rather larger than usual: about 30in square. It was the cover of a book of essays on the nature of thought. The mask symbolizes the face we present to the world, the red flash the moment of insight or inspiration which opens a new area or phase of thought to us.

Cover, *Thinking on the Edge*, anthology edited by Aidan Kelly, Agamemnon Press, 1993

Below right:

Plugged-In Cyber-Girl

Scratchboard and India ink: 5½in x 7in (13.5cm x 18cm)

This is one of 100 interior illustrations – I also painted the cover – done for the story collection *The Gateway Trip* by Frederik Pohl. I was given the manuscript for the new book, but the descriptions for reference were drawn from the author's five existing Heechee novels, which I hadn't read in years. To help me, Laura went through the books, initially hand-copying extracts and then, when this grew laborious, drawing the descriptions. I liked her rendition of 'Hereafter Immortality Parlor' so much that I simply rendered it as it was, and so I signed it with the double "bug", KFL, to indicate it was a joint effort. The girl is in the process of having her essence captured so that she can communicate with her descendants – whom she will find quite boring: after all, she is electronic and they will be merely oh so slow flesh and blood. This has become one of our favourite pieces.

Interior, *The Gateway Trip: Tales and Vignettes of the Heechee* by Frederik Pohl, Ballantine, 1990, and Easton Press, 1990; also available on a mug

Other books by Frank Kelly Freas:
The Astounding Fifties (1971), *The Art of Science Fiction* (1977), *A Separate Star* (1984)
Many of the illustrations in this book are available also as prints from www.kellyfreas.com.

First published in Great Britain in 2000 by Paper Tiger
an imprint of Collins & Brown Limited
London House
Great Eastern Wharf
Parkgate Road
London SW11 4NQ

www.papertiger.co.uk

Distributed in the United States and Canada
by Sterling Publishing Co.,
387 Park Avenue South, New York, NY 10016, USA

1 3 5 7 9 8 6 4 2

British Library Cataloguing-in-Publication Data:
A catalogue record for this book is available from the British Library.

ISBN 1 85585 848 7

Designed by Malcolm Couch

Reproduction by Global Colour, Malaysia
Printed and Bound in Hong Kong by Sing Cheong

Contents

Foreword 6
by Tim Powers

Preface 8
Introduction 10

Getting Started in Painting 16
Illusion in Art – and Life 26
Some of My Best Critics Are Friends – or Vice Versa 38
I Don't Know What's Good, But . . . 50
In Defence of De Philistines 58
Selling Books 66
Robots and More Robots 76
What, Art? What Art? 82
The Way I Work – More or Less 88
On the Painting of Beautiful Women 96
A Separate Universe 102
About Kelly and Laura Freas 110
Index of Works 112

Foreword
Tim Powers

I REALLY THINK I wouldn't have got married if it hadn't been for Kelly Freas.

I was working in a Tinder Box tobacco shop in 1978, and I wanted to impress Serena, the beautiful auburn-haired girl who worked in the jewellery store down the row, so one time when she came in to buy cigars for her boss, I gave her a copy of my first published book. It was one of the line of Laser Book paperbacks, a particularly handsome one – I was almost prouder of the Kelly Freas painting on the cover than I was of the text between the covers.

Serena's blue eyes widened, and then focused on me for perhaps the first time ever. 'You know Kelly Freas?' she asked, in a tone of real awe.

I was suddenly much more impressed with her, too. 'Sure,' I said.

And, much like Cortéz when with eagle eyes he stared at the Pacific, she and I 'look'd at each other with a wild surmise.'

Two years later we were married.

In that initial moment of dazzlement, though, we were, via Freas's work, ascribing more to each other than was yet there. Serena knew hardly anything about science fiction – but she had been a fervent fan of the rock group Queen ever since their first album in 1973 and, while listening to their 1977 album *News of the World*, she had of course stared at the two paintings that filled the album's inner and outer cover surfaces. Those were two views of a giant, sad-eyed robot leaning in through the broken roof of a concert hall, helplessly crushing the band members and people from the audience.

I might not have known much about Queen, but I did know that robot – I'd been an avid science-fiction collector all my life, and that strikingly sad-eyed mechanical man had first appeared on the cover of an issue of *Astounding* in 1953, the year after I was born.

I hadn't seen it then, of course, but by the time I was seven I had seen many of Freas's vivid paintings in *MAD* magazine; and, when a few years later I discovered science fiction, Kelly Freas's work became one of the main windows through which I explored all those astonishing new worlds.

Those fictional worlds became far more tangible through his paintings and drawings than the authors alone could ever have made them. In a Freas picture, crystals glow with an inner fire that mere coloured paper shouldn't be able to contain – jewels mounted with obviously specific purpose in the gleaming silver complexities of futuristic gadgets, water-drop gems in the heads of tiny mechanical beetles and at the muzzles of very business-like ray-guns . . . and those guns, and the buckles, and the bodies of spaceships and robots! No painter has

Above:
The Skies Discrowned
Acrylics: 15in x 20in (38cm x 51cm)

This was one of the Laser Book novels I particularly liked, even aside from the opportunity it gave me to paint a fake gold ear, a fancy sword and a Freas mushroom-patch space-ship in the same picture. The fact that I read the manuscript before all the editors got to it may have made a difference – Laser Books had a tendency to 'lose' large blocks of story. Speaking of stories, please refer to the Foreword to find out what the author of *The Skies Discrowned* has to say about it.

Cover, novel by Timothy (*sic*) Powers, Laser, 1976

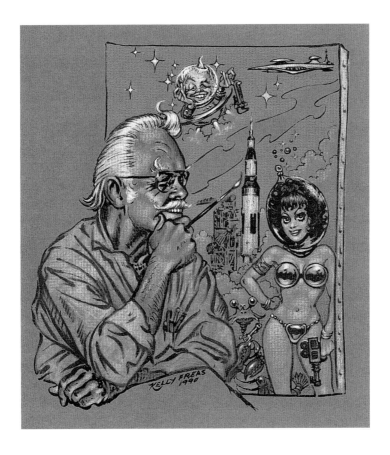

Above:
Self-Portrait
Acrylics: 15in x 20in (38cm x 51cm)

No doubt flattering, but recognizably Kelly, with attendant spaceships, alien (*alter ego*) and pretty girl: Laura, of course, in bronze chastity belt and brassiere, the obligatory costume of 1950ish *Planet Stories*.

Back cover, catalogue for touring exhibit of *MAD* magazine art called 'Humor in a Jugular Vein', San Francisco Cartoon Art Museum, 1991–2; also used as an interior in *A Gallery of Rogues: Cartoonists' Self-Caricatures*, edited by Robert C. Harvey, Ohio State University Cartoon Research Library, 1998

ever captured steel in all its textures as effectively as Freas has – whether it's pitted, brushed, polished a thousand times or mirror-bright, or even melted and resolidified in surrealistic static splashes as grainy as starfish-hide – your fingers can feel the satin and the coolness and the solid unyielding mass.

These aren't worlds inhabited by generic fresh-faced space cadets, either. The faces of these people are scored with all the rapids and oxbows of life's real rivers – in a haggard face tense with apprehension you can see old mirths, satisfactions and disappointments, even a hint of the long-lost youth. The alien faces are expressive of emotions intriguingly comparable to but not identical with our own, and even the robots can express everything from officiousness to nobility.

Writers should hope to convey character half as effectively!

Serena is now very familiar with the many worlds of science fiction, and I've become a Queen fan. The world has gone on expanding since I was a kid reading *MAD* magazine and, later, the old Ace Double science-fiction novels – but still, when I see stars shining through fog, or sunset light on the folds of green hills, or the weathered faces of old soldiers, my reflexive association can be expressed as, 'I've seen this before – in a Kelly Freas picture.'

Preface

This will be the third Preface I have written for this book. The return of Kelly – after over a decade really does require some up dating...

Many of you will recall that, when Polly died, I sold my house in VA and moved to CA. That was as far away as I could get without taking a boat; I was watching pennies. During Polly's illness, fan-friends and others had contributed some 40K toward medical expenses. Now it was gone, Polly was gone, and so was most of me.

That rambling monster in the Great Dismal Swamp sold for a measly 130K. Then it stuck me for an unanticipated 30K in repairs of hidden damage. I thought I had maintained it properly, but I was wrong.

The kindness of people and the tender-loving-care of my friends was a revelation to me. There is truly no way I could thank them: too many and too much. The Hampton Roads science fiction folk turned out en masse to pack books, clean house, and pat me on the head. "Here's a beer, Kelly. You just sit there and DON'T MOVE!"

Suffice it to say, they got me on my way – and some of them even rode herd on me for a time, I think mostly to keep me out of trouble... Worked, too. Mostly...

There were some flattering bits of rumor afloat, about my doings,

highly entertaining, if not entirely accurate. Like the one that I had gone to La-la Land, lost my mind, and married a teen-age starlet. She wasn't exactly teen-age, and she wasn't a starlet. And I had _not_ lost my mind. I had simply decided to embalm myself in bourbon, thus saving the government money and assuring myself a speedy and well lubricated demise.

The first serious rift in my embalming plan was presented by Algis Budrys' invitation to take on the job of Coordinating Judge for the projected "Illustrators of the Future" contest. I would choose my own panel of judges, travel all over the country, give lectures, attend conventions. All expenses paid, and a reasonable stipend... Doing well by doing good, as the song has it. I packed my socks and medicine bottles - all of them - and took to the air. It was a great idea, and it brought talent out of the woodwork like mosquitoes to a midnite soirée. Talent? Many of them are established illustrators by now, and I thank whatever gods there be that I don't have to compete with _them_!

After Laura and I were wed, life became a beautiful blur. She was in radio (remember "Music Thru the Nite" on public radio?), and all was well until her station went automatic and fired all the humans. It's enough to make one a Luddite.

Shortly before that I had begun to rack up medical and dental expenses at an astronomical rate. I was spending more time in doctor's waiting rooms than I spent at the drawing board. Rather quickly, all the peripheral occupations had to be dropped as my production slowed, and its quality careened toward abysmal.

Laura took over. She also took my bourbon, which had resisted dog's years of medical pressure. She insisted that I eat, instead of drink (she is a superb cook, by the way). When I complained that chewing hurt my teeth, she made horrid little messes in the blender, or the juicer, and somehow made them palatable. She virtually eliminated fats (yum!) and all salt (gag, gasp). I gained back all the weight I had lost, started working again.

Laura is a good critic, and an equally good (and published) artist. She thinks like an illustrator, too. Before long I was getting more compliments on my work too. She has that effect on people...

Everythin' considered, I think you can safely say that Kelly's back and Laura's got him. I hope you like my new work as well as ever, and tell me about it. Your input is a big help to me - and I plan to be around for a lo-o-o-ng time. Stick with me!

Selah –
Kelly Freas

9

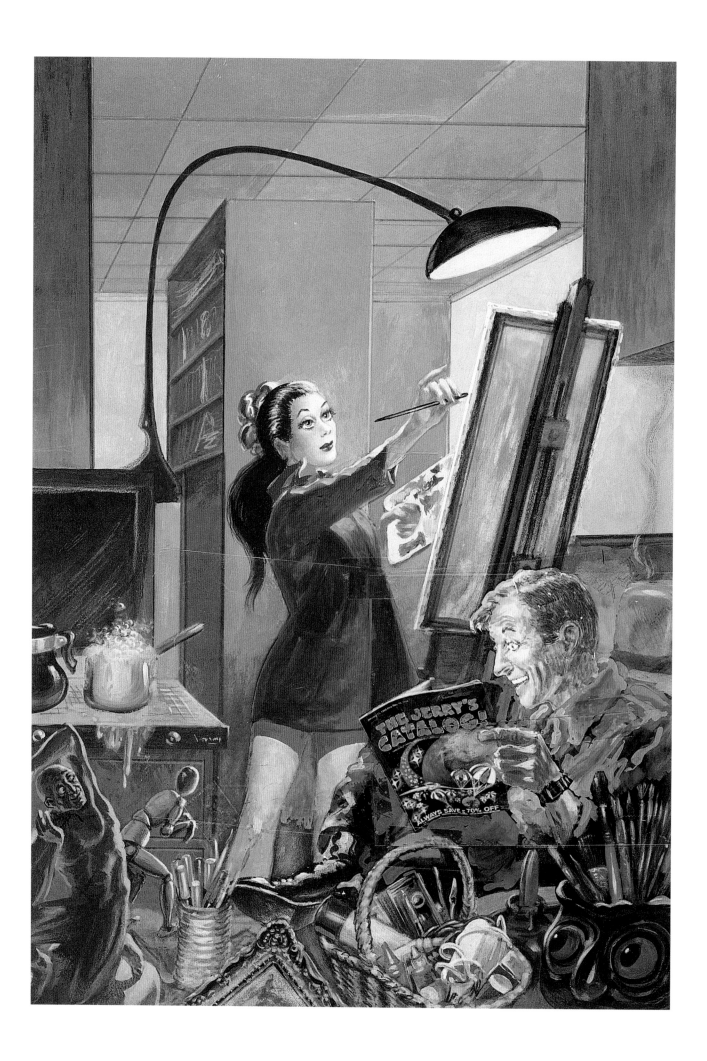

Introduction:
As He Sees It

. . . and Each in His Separate Star
Shall Paint the Thing as He Sees It
For the God of Things as They Are . . .

NOBODY EVER MENTIONED, to my knowledge, that some of us see, as well as think – sideways.

I have always avoided thinking of myself as an artist. I am, first and foremost, an illustrator. There are several million ideas milling around out there, most of which, in order to be understood, need expression in a medium other than verbal. To wit, visual. Enter Kelly Freas. John W. Campbell Jr, for several decades editor of *Astounding/Analog*, had once admitted the principle: if it can't be illustrated, give it to Freas.

He thought sideways, too. The job of an illustrator, according to me, is (1) to read and understand a story or article, and (2) to illustrate it with, ideally, the ideas which, for reasons of space or simply the limitations of mere language, the author can't *write*. After all, a complex background might take several pages to describe in type, yet be communicated at a glance when illustrated. Then, too, a background can imply any number of things that the author wants to keep obscure at the beginning of the story. The second thing the illustrator can do, usually with black-and-white interior drawings, is clarify situations or objects for the reader, making verbal explanations unnecessary.

To do either of these, however, the illustrator must, as in proposition (1), read and understand the story. Ideally he will become (for himself) the author's *alter ego*, absorbing the writer's viewpoint and expressing that viewpoint – the writer's, not his own – in visual terms. I really have little patience with illustrators' so-called 'self-expression'. Most of the people who make a fuss about self-expression have undue concern over a self that has little of value to express. 'I say it's spinach, and I say, "The hell with it!"'

So why am I writing all this? Shouldn't I let my pictures speak for themselves? I don't think so. The

Left:
The Jerry's Catalog
Acrylics: 15in x 20in (38cm x 51cm)

My second cover for Jerry's Artarama. Once again, the image of my wife made the cover a success. However, she is upstaged this time by the cover of the catalogue her man is reading – my previous handiwork for the same company! It's a great source of satisfaction to be allowed to quote from oneself.

Cover, *The Jerry's Catalog*, January–May 1997

Right:
Dick Scobie
Acrylics: 15in x 20in (38cm x 51cm)

A memorial portrait of the commander of the ill-fated *Challenger* mission. Rather than point up the tragedy I chose to focus on the vision and the promise, with *Challenger* on the launch pad in the background. This was a private commission, so the original was out of my hands; however, I gave a print to the commander's widow and daughter.

Private Commission, early 1990s

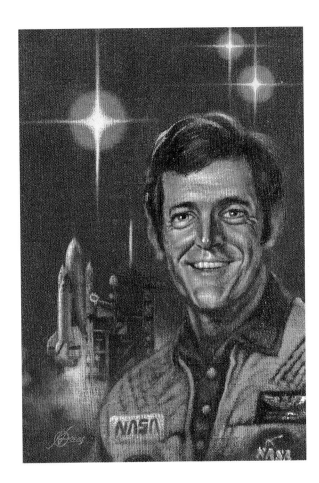

Deadline Job: Teamwork – That's What Does It

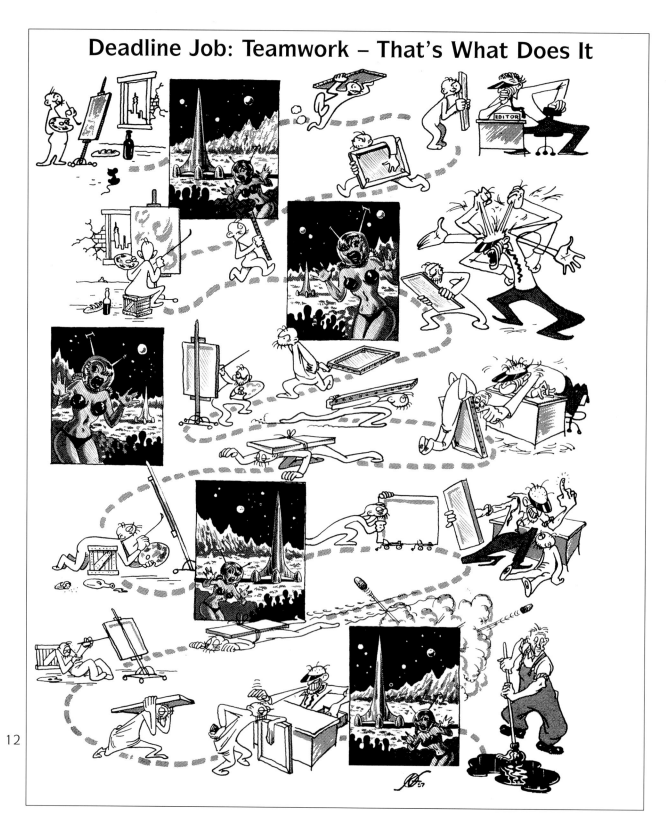

Above:
Deadline Job: Teamwork – That's What Does It
Pen and ink on board: 9in x 12in (23cm x 30cm)

An expression of personal opinion, only a slight exaggeration of an illustrator's dealings with an art director.

Inside back cover illustration (no story, just page decoration), *Science Fiction Times*, September 1, 1957, volume 12, number 128. Published by Fandon House, Paterson, New Jersey, USA. James V. Taurasi Sr., Ray Van Houten and Frank R. Prieto Jr., Editors. (16th anniversary issue)

Right:
Side Bet
Acrylics: 15in x 20in (38cm x 51cm)

Imagine anyone fool enough to bet with an entity that has traded one eye for the ability to see the future? Mercury never was given credit for being overly smart anyway. The art director insisted on a chariot race in the foreground, so we decided it might be interesting if we made it a race between a Roman horse and a big Egyptian panther. As the mixed pantheon of gods looks down upon their intervention yet one more time into the course of human affairs, the final touch was to give them joysticks.

Cover, Dragon Magazine #153, December 1989

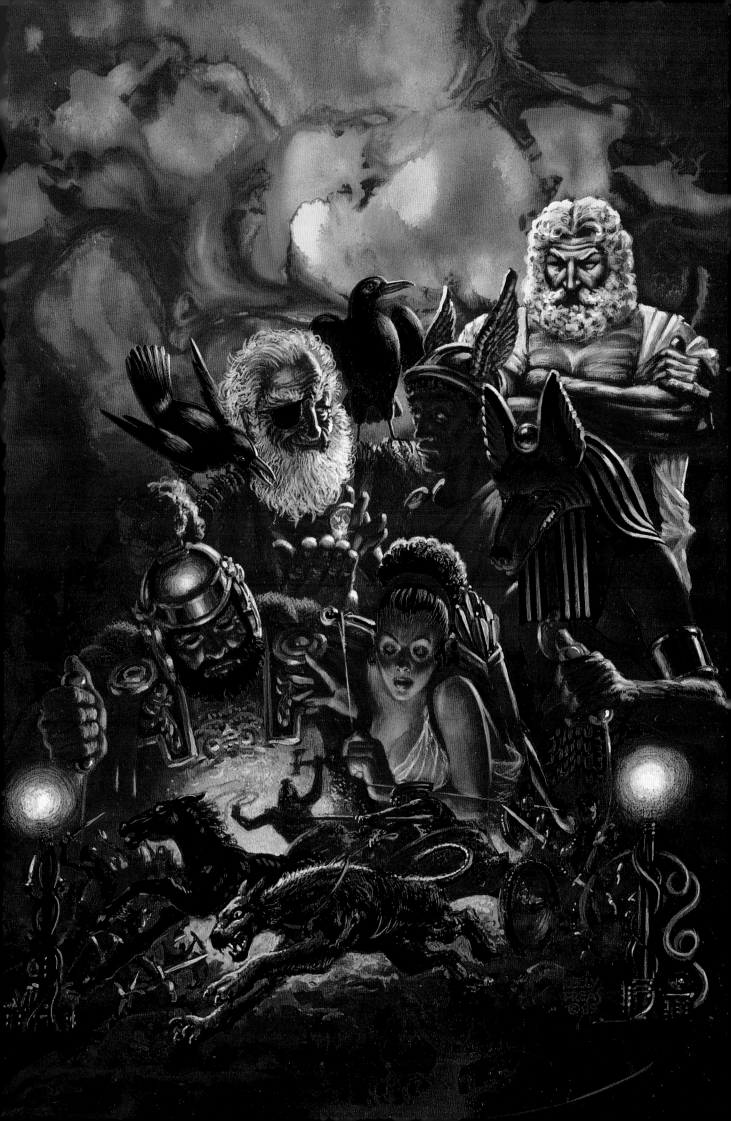

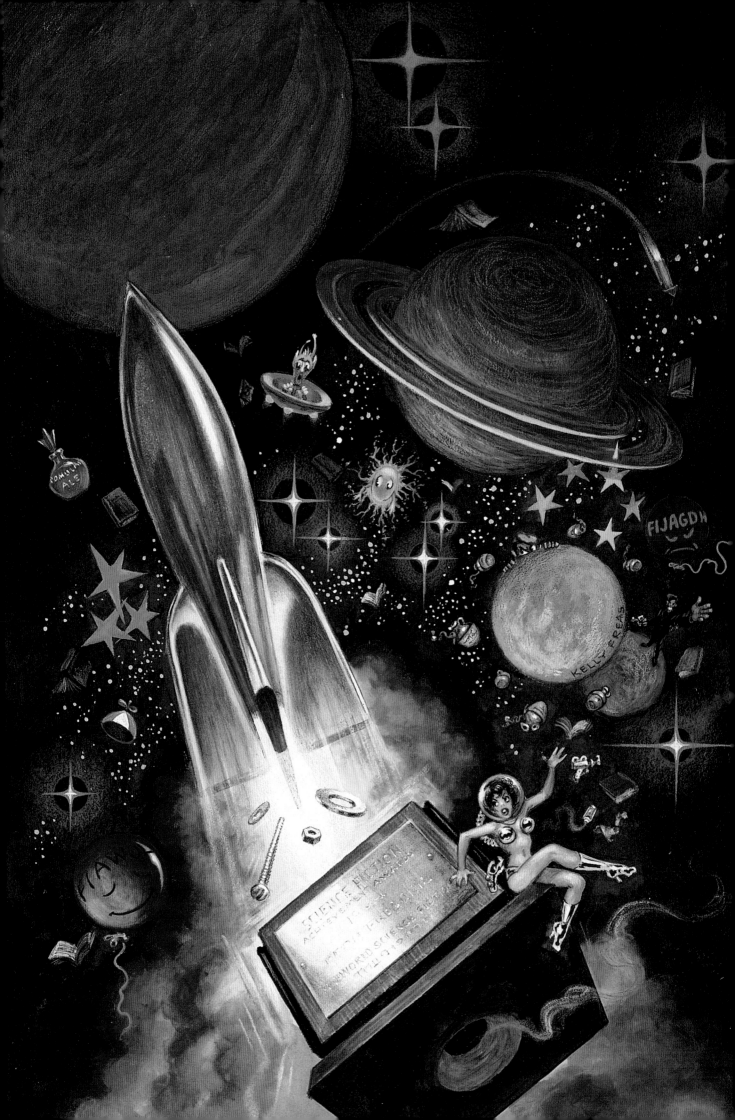

best illustrations and stories make, together, a package considerably greater than the sum of its parts. If, of course, you have read the particular story concerned you won't need my comments unless you are interested in why I chose to illustrate it the way I did, and what my reasons were. They are not always obvious, but I hope they are always appropriate.

Illustrating a story is almost always a pleasure. I say 'almost' because there are indeed some stories that are well nigh unillustratable. The best of those require that the artist (I'm going to use that word because it's shorter and easier to write in longhand) saturate himself with the story, enter its world, and find something relevant to draw. For some, however, the artist is reduced to merely decorating a page. This is the point at which you thank heaven for pretty girls – and interesting gadgets. Even in the latter case, though, it's still a pleasure.

In fact, it's hard to imagine the practice of illustration to be less than a pleasure. That isn't to say that it may not be hard work – it's a good bet that artists burn even more midnight oil than writers. Among other things, we are usually working to short deadlines and sharp judgements.

My approach to doing an illustration is, perhaps uncharacteristically, quite organized. The first step, of course, is to read the story straight through. Then I get a sketch pad and reread it, making doodles of ideas as I go, and notations of their placement in the story – the purpose being to position them at roughly equal intervals.

The next step is to sketch in more detail the situations I have chosen for the illustrations and

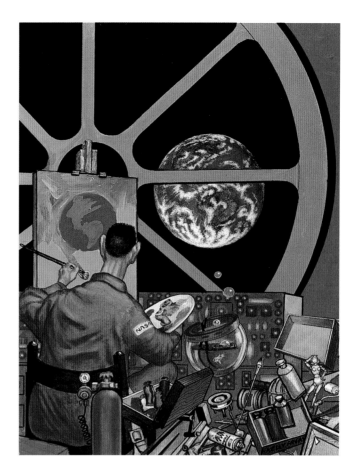

begin looking – both in the story and elsewhere – for material necessary to flesh out the idea. This may sometimes involve research into specific subjects: for example, what exactly is the array of multiple jets for a freight rocket as compared to a personnel carrier?

When the sketch is satisfactory I transfer it to the final drawing surface, and the ink rendering is then quite straightforward. Covers are done in much the same way, with the addition of several colour sketches to establish the overall colour scheme, which are carefully scrutinized by everyone involved in the final production to choose the one for the final rendering.

Then I go home and can work all night to deliver the 'finish' by the morning. And I will (I hope) be appreciated: by the editor because I've delivered the job on time; by the writer because I've understood his thinking; by the printer because I gave him something his presses could handle without irritating his ulcer; and, above all, by the reader. Yes, *you* . . . because your enjoyment is the object of the whole exercise.

I hope the work in this book will add to your enjoyment of, and perhaps even stimulate you to look up, some of the stories that it has been such a pleasure for me to illustrate.

Frank Kelly Freas
West Hills, California
2000

Left:
The Super Hugos
Acrylics: 15in x 20in (38cm x 51cm)

A Hugo – science fiction and fantasy's annual award for excellence – heads into the wild blue. I can (modest cough) vouch for the image's authenticity, having received ten of these awards over the years.

Cover, anthology edited by Isaac Asimov, Baen, 1992

Above right:
Space Artist
Acrylics: 15in x 20in (38cm x 51cm)

A nod to astronaut/artist Alan Bean: in this fantasy scenario, all his equipment floats in zero gravity. It is surprising how easily the floating effect can be obtained by comparison with the difficulty of making things sit or stand on a surface, as in the usual picture. The clients liked the subliminal message that their products go everywhere – even to outer space.

Cover, *Artists' Supply Warehouse Catalog*, January 1999–January 2000

Getting Started in Painting

ALL THEORIES OF ART aside, there are three prerequisites for the production of a painting:

* something to make your picture *on*
* something to make it *from*
* something to make it *with*.

The *on* is simple enough – a coat of acrylic matte medium or acrylic gesso, applied to a clean, dry, non-oily surface (conditions you can readily produce one way or another) will make it possible for you to paint *on* practically anything and, indeed, *with* practically anything (but see below). Such technical concerns as permanence, texture and handling can come later. For now, just find something flat and do a picture on it.

The *from* is a mite more complex, being two-pronged – because there are two places you can find your subject: it may be in your head or 'out there' somewhere. Either is perfectly valid. 'In there' may sound easier, since nobody else can tell you that you aren't painting it the way you see it, but *you* know. It can be extremely frustrating to have a vision of jewel-like clarity and glowing, luminous colour turn into an amorphous mess of greyish mud somewhere between your head and the canvas. It happens. Don't fret – just scrape it off and start again. You have the vision. The vision *wants* to be realized. You provide the labour – and the patience. Oh yes – it's all right to swear a little and throw things, but do it quietly and in private. Don't scare the horses.

From, prong two: out there. It's easy to confuse cart and horse here. You are trying to paint a potful of peaches, and it won't come out. OK. The problem is not that you can't paint it – any jackass who can write his name can paint it (his name, that is) – but that you don't *see* it. You have to forget what you think you know, and *look*. Simple enough. You already know that the pot which is circular looks oval. You also know that the oval of its top edge looks different from that of its bottom . . . Well? Do you *see* it? Which one is fatter? By how much? Now – you've got it. But look at that left-hand peach. You *know* that any sphere, highlighted from one side, has a dark shadow on the other. Except this one. All you can see is a perfectly flat disc – no sphere. Look a little closer. Note the way the light is reflecting from the bowl onto the peaches – and from the peaches onto each other . . . *of course!* – the stupid thing is catching a reflected light which effectively eliminates the shadow. You paint it that way, in proper relationship to its peachy companions, and everything falls into place.

You paint what you see – not what you know, but you have to *teach yourself* to see. That's something

Live Coward
Pen ink on board: 5in x 7in (13cm x 18cm)

Interior, *Astounding*, June 1956, illustrating the story by Poul Anderson

Right:
The Door into Summer
Acrylics: 15in x 20in (38cm x 51cm)

Many times while painting this I longed for the good old *Planet Story* days, when I could have painted a nice sexy semi-nude trying to keep warm on a large ice cube. But the client wanted something restrained and 'tasteful'. After several efforts we came up with this one – the girl comfortably asleep in a cosy refrigerator – which satisfied all requirements including those of the model: she slept through the whole thing.

Cover, *Magazine of Fantasy & Science Fiction*, October 1956, illustrating the serial by Robert A. Heinlein

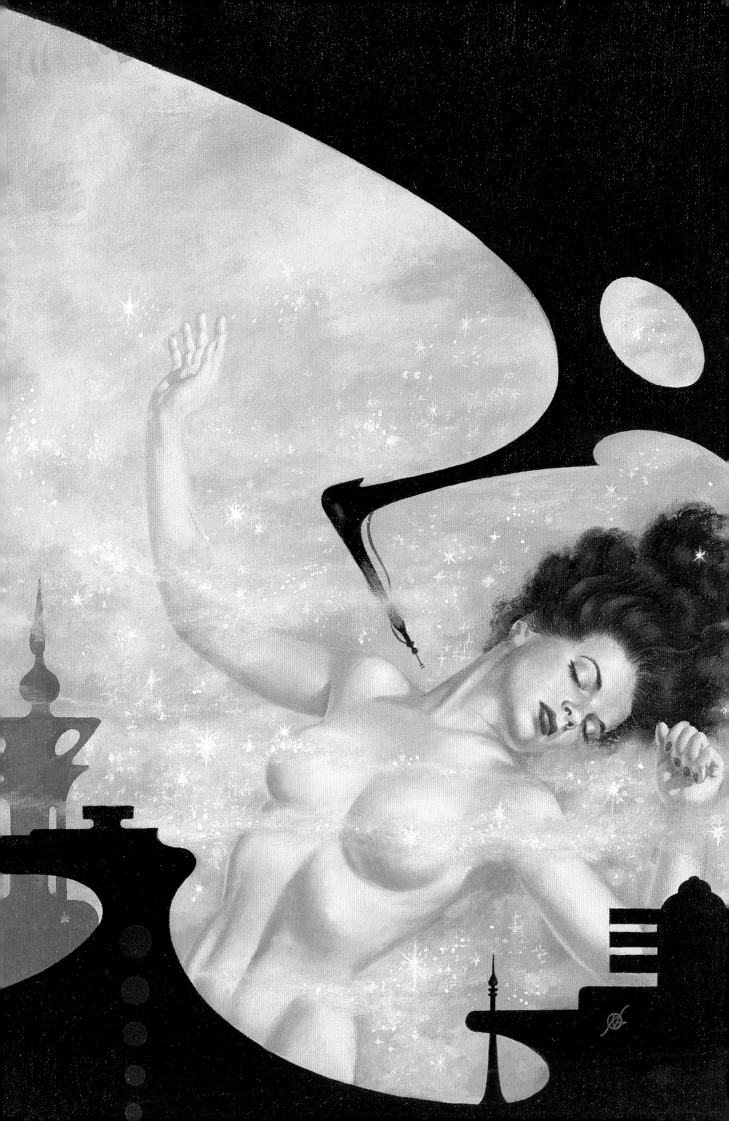

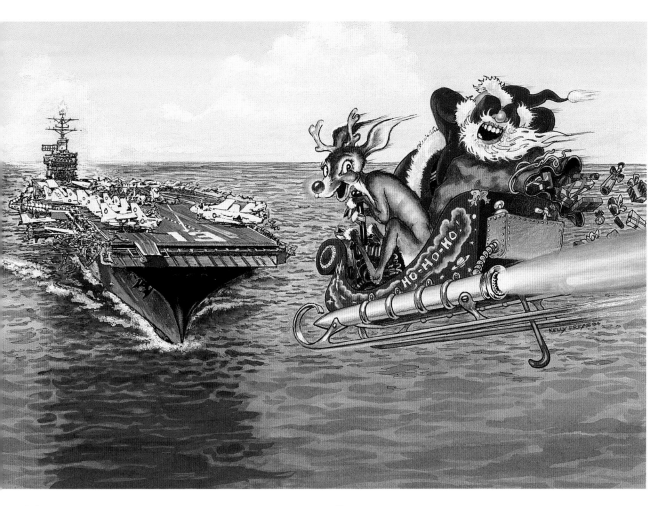

Left:

Marauders of Gor

Acrylics: 15in x 21in (38cm x 51cm)

When I got this assignment the prohibition against sexy covers had relaxed a bit, but was still polluting the editorial atmosphere. Blood and guts were quite acceptable but seemed inappropriate, for some reason. Our solution was the use of a tasty leg – and a lot of reader imagination.

Cover, novel by John Norman, DAW, 1975

Above:

Incoming

Acrylics: 20in x 15in (51cm x 38cm)

Close inspection will reveal crew members jumping ship as Rudolph brings in Santa's updated sleigh to a carrier landing – **from the wrong direction!** The client had a picture on his office wall of the carrier he had once served in, and wanted it shown in this illustration. He got his wish.

Lead interior illustration, 'Holiday Buyers' Guide', *Computer Gaming World*, December 1994

nobody else can do for you (thank God!). All that the greatest teacher in the world can do is to point you in some direction or other and say, 'Look!'

Now for the third element of the potential painting, something to paint *with* – essentially, substances (mud, soot, red paint) that will make a visible mark on a surface, plus a stick, a spray can, or your finger to convey it from wherever it is to wherever you want it to be.

The point is that you can do a lot with very little; you can in fact use anything you have available to practise your own private art. So long as you *keep* it private, not a soul in the world (including you) has any right to say that *your* art, on its own terms, is any less valid than that of a Michelangelo or a Picasso.

(However, if you insist on giving your master-pieces as Christmas gifts to your relatives and friends, you may find that the former soon outnumber the latter. This rule applies even to well established artists. 'Art given away by the artist is *never* appreciated. NEVER.' Engrave that on your easel in letters of fire.)

Of course, you want brushes. Get six:

* three large, squarish and stiff
* three small, pointy and soft.

The big ones block in your picture and cover large areas fast. They also allow you to make broad soft edges by dipping into a dark colour on one side and a light one on the other: when you drag the brush across the surface the two tones blend together in a nice spontaneous mixture. You use the small, soft brushes to carry relatively fluid colour, to apply it over the previous layer of

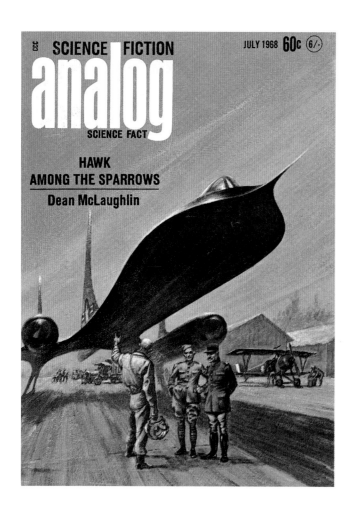

SCIENCE FICTION

analog

SCIENCE FACT

JULY 1968 60c 6/-

HAWK
AMONG THE SPARROWS
Dean McLaughlin

Left:
Hawk Among the Sparrows
Acrylics: 15in x 20in (38cm x 51cm)

Talk about research problems – In the end practically everything I did was wrong, except the truck in the background. At the time of the story, the Americans (I was subsequently informed by a reader) were still wearing French uniforms; the engine cowling didn't arrive until two years later; the French officer was out of date, etc., etc. You definitely *can't* win them all – there's always some expert out there who knows more than you do, no matter *how* much research you do.

Cover, *Analog*, July 1968, illustrating the story by Dean McLaughlin

Right:
Pandora's Planet
Acrylics: 15in x 21in (38cm x 51cm)

One in a run of conquer-Earth-at-your-own-risk-sucker! tales, the entertaining and perceptive story clearly invited the symbolic (or is the word 'mythical'?) treatment I gave it. A minor problem was that readers identified me as the model for the soldier. Presumably they also identified the model for Pandora, but never dared say so . . .

Cover, novel by Christopher Anvil, DAW, 1972

paint without lifting it, and to sharpen details where needed.

You may also want painting knives – rather like miniature spatulas – to smear large gobs of pure colour where desired, or to mix colours on your palette. You may use wads of old newspaper or lots of paint rags to clean your brushes with. Most artists do – although personally I loathe both. I like Kleenex for wiping brushes while working, and thick, soft paper towels for cleaning up. So, it's unprofessional and expensive? It's worth it. Rags are indispensable only for wiping out mistakes: a couple of old T-shirts cut into pieces about six inches square will be ideal – highly absorbent and quite lint-free.

Clear all of the debris out as soon as you finish your work each day. It is a fire hazard and it usually stinks.

I do not recommend particular clothes for painting in, unless you want to wear designer jeans and a silk shirt. The trouble with a smock or even old blue jeans is that it's almost impossible to resist wiping your hands – or your brush – on your clothes when you're in a hurry. But when you're painting you're *always* in a hurry, and the habit, once acquired, is virtually impossible to break. I have ruined more good trousers than I can remember.

Whatever medium you use, keep:

* a large container of the solvent for rinsing brushes
* a smaller one for mixing (you dip into it, with a more or less *clean* brush)
* a squirt bottle to dispense a drop or two when needed (you may have a brush loaded with a colour mixture you don't want to risk by dipping, so a drop of medium on the palette solves the problem).

I like peel-off palettes: you can buy them in several sizes, and the little ones can be very handy at times. If you have lots of room and don't like cleaning up every day, a big chunk of plate glass is nice but not very portable.

As for an easel, get either a portable one or the biggest, heaviest monster you can afford. Anything in between isn't worth the trouble. Except for portraits, which are the only things I do larger than about 20in x 26in, I seldom use one. I prop my picture against the edge of my drawing table, at whatever angle I need. (I can't tilt the drawing board, though: it's covered with overdue library books, unanswered mail, reference photos, hand tools, clock parts, tape cassettes, ink bottles and peanut-butter sandwiches I forgot to eat.)

I'm treading on dangerous ground here by trying to enumerate rules . . . I'm going to play it off the top of my head:

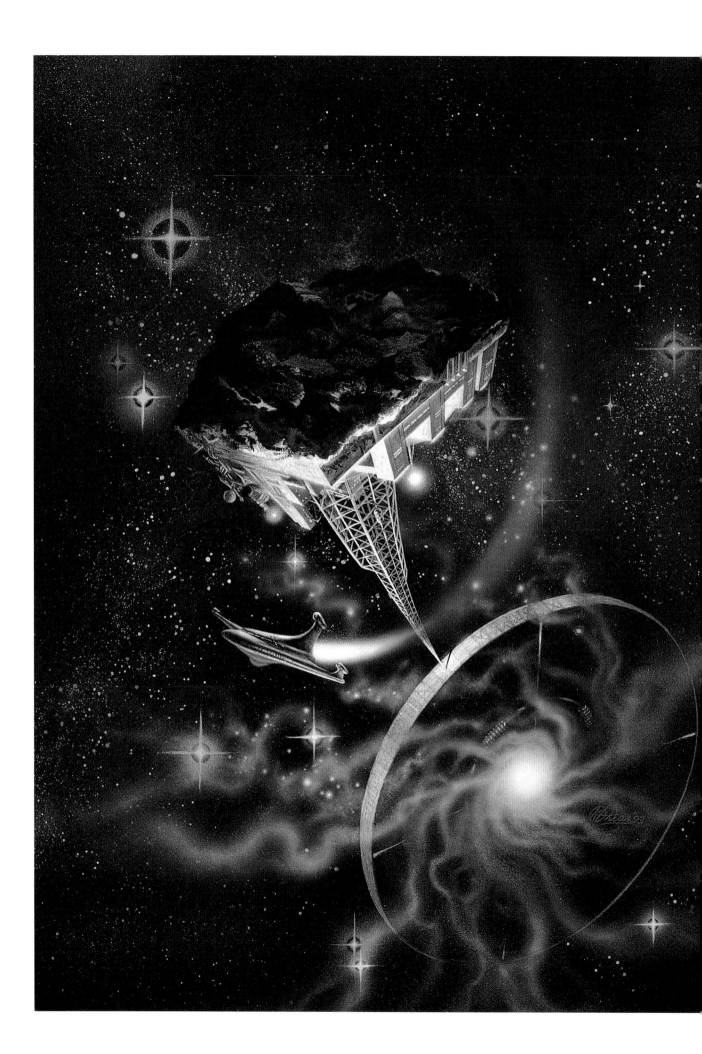

Above:
We Make Giant Lenses
Acrylics: 15in x 20in (38cm x 51cm)

I hope *somebody* does! To get the reflections and variations of light I had to cast the lens in colourless Jello and then mentally remove the flaws as I painted. Maybe it was hardly worth the trouble, but . . .

Unpublished, early 1990s

Left:
Research Station
Acrylics: 15in x 20in (38cm x 51cm)

An annular station, at the point of one-half gravity out from a quantum black hole, provides the footing for research. Headquarters is an asteroid tethered a safe distance above.

Cover, *Amazing Stories*, November 1993

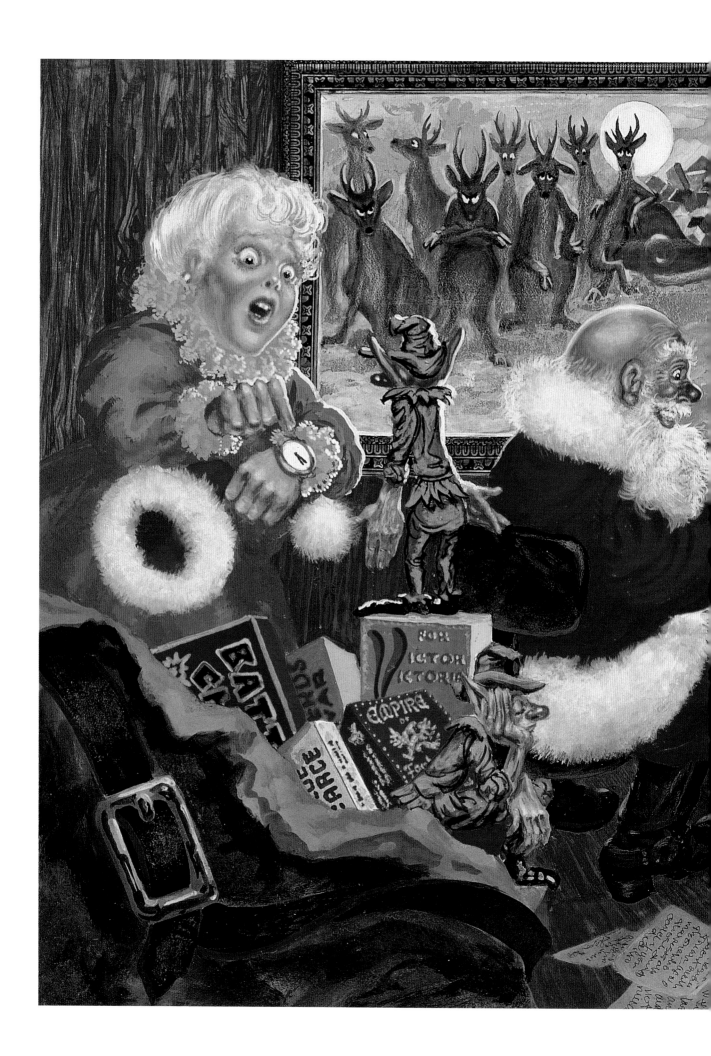

* When in doubt, don't think. *Do.*
* Emote, don't analyze.
* If it feels right, do it.
* If it doesn't feel right, don't!
* (And this last is merely the obverse, or the reflection, of the first.) Choose *now.* Recover later.

Let's elaborate – as little as possible.

* As I have suggested before, you *know* a great deal more than you think you know. For our purposes, we can dispense with the usual concept of the subconscious – or let us assume that the subconscious is merely a roomful of file cabinets, some of them covered with cobwebs and rusted shut from neglect and disuse. But they *are* there, they *belong* to you, and only *you* have the ability (and the *right*) to open them. So it may take a hammer or a drill on the lock? It's *your* lock. Let the feeling, if any, come through.
* Painting is a right-brain function. Analysis is a left-brain function. They do not ever work well together. However accurate, perceptive or erudite your left-brain analysis may be, it will inevitably rob your painting of whatever vitality it began with.
* This is an area in which you *feel* your way along. If you have done your homework, all of the *logical* problems should have been solved before you started to paint.
* Now you come up against a subject or a colour balance or a value that just doesn't jell. So scrap the logic and follow your instinct.
* If it's wrong, you have only lost one picture: you will *know* you blew it, which is something no critic can tell you. And you will now have a pretty good idea of how to do it right. Make your choice and act.

Most of the knowledge is already there in your head. All you have to do is scrape away the debris (of generations of hogwash, years of misinformation, and the inevitable but usually ridiculous personal inhibitions). It really isn't as tall an order as it sounds.

First step – just paint. Whatever.
Analyze later.

Left:
Yes, But He WON'T Go!
Acrylics: 20in x 15in (51cm x 38cm)

All in all, a fairly straightforward painting. Santa is fascinated with his new computer, while his elves stew in frustration. A stroke of inspiration brought in the team of impatient reindeer, with Rudolph about to blow his top.

Lead interior illustration, 'Holiday Buyers' Guide', *Computer Gaming World*, December 1993

25

Illusion in Art - and Life

TO THOSE WHO HAVE made any direct investigation of matters occult, transcendental, metaphysical or simply peculiar, the fact that the world we know is all an illusion is accepted almost without question. We are, legitimately enough, I think, more concerned with the anatomy of the illusion. In the most basic philosophical sense, it is no more miraculous that a human being should levitate or bilocate than that he should be able to walk or jump. We do not tell Uri Geller that he can't do it. We say, 'Tell us *how*.' On the other hand, we don't ask Barbara Walters or Trevor McDonald to verify their sources. We simply ask how accurate is that part of their information we can check, and extrapolate from there.

Unfortunately we often forget that most of our so-called explanations (especially *scientific* explanations) finally rest on a cosy heated waterbed of faith. All else failing, we have an almost ineradicable belief that, even though *we* personally don't have any explanations, or don't understand those we do have, *somebody* else simply *must*. There are many who believe that the somebody is God. But, whether we address our prayers and complaints to Jehovah, the President, Einstein, or simply the Occupant, we do at some point concede that there is more to the mortal coil than meets the mortal eye.

My particular speciality happens to be that mortal eye, and the methods of manipulating and exploiting its inherent characteristics.

Here's an aside to explain what I mean:

The human eye as constructed – or *evolved* – is flatly incapable of focusing a red and a blue of equal value (that is, tonality between light and dark) and equal intensity of saturation (the actual *amount* of colour or hue present in a mixture – all experimental colours except an actual spectral or prismatic colour being mixtures). The human eye, as I say, *cannot* focus this red and this blue on the same plane.

By judicious use of this one inherent characteristic of human vision, the artist can impart the *illusion* of space, the *illusion* of movement, and the *illusion* of interacting spatial and temporal planes.

Now, latch onto this next one, friends: it's vital. *Nothing* happens in the picture. It just sits there. What happens all goes on in your head. Your

Left:
The World Menders
Acrylics: 15in x 21in (38cm x 51cm)

A mother ship in orbit sends a scout to look over the new planet. So far so good. Unfortunately this was done before our tech-whizzes had decided that a vertical tail fin in a shuttle ship was redundant. You can't win 'em all.

Cover, *Analog*, February 1971, illustrating the story by Lloyd Biggle Jr

Below:
The End of Summer
Pen and ink on illustration board: 8in x 10in (20cm x 25cm)

Interior, *Astounding*, November 1954, illustrating the story by Algis Budrys

28

Above:
The Lensman
Acrylics: 15in x 20in (38cm x 51cm)

Cover for a game box. A new audience (teens and younger) see Kimball Kinnison and his sidekick, Worsel the Velantian, shoot up the area with Galactic Patrol lenses out-glowing the stars (and explosions) that surround them. The eyes in the background symbolize the evil influences attacking them.

Cover, game box, Steve Jackson Games, 1993

Right:
The Maelstrom's Eye
Acrylics: 15in x 20in (38cm x 51cm)

A battle with swords and axes on the deck of a very peculiar submarine would seem to require some explanation, I'm sure. Would anyone care to come forward with one?

Cover, *Spelljammer: The Cloakmaster Cycle #3* by Roger E. Moore, TSR, 1992

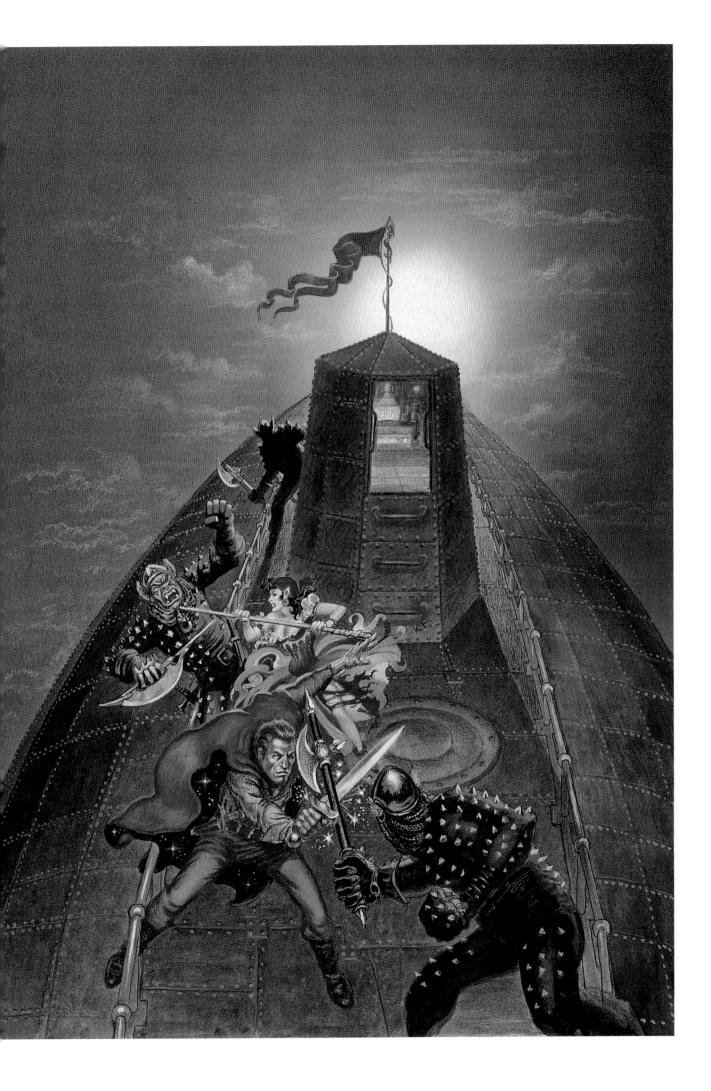

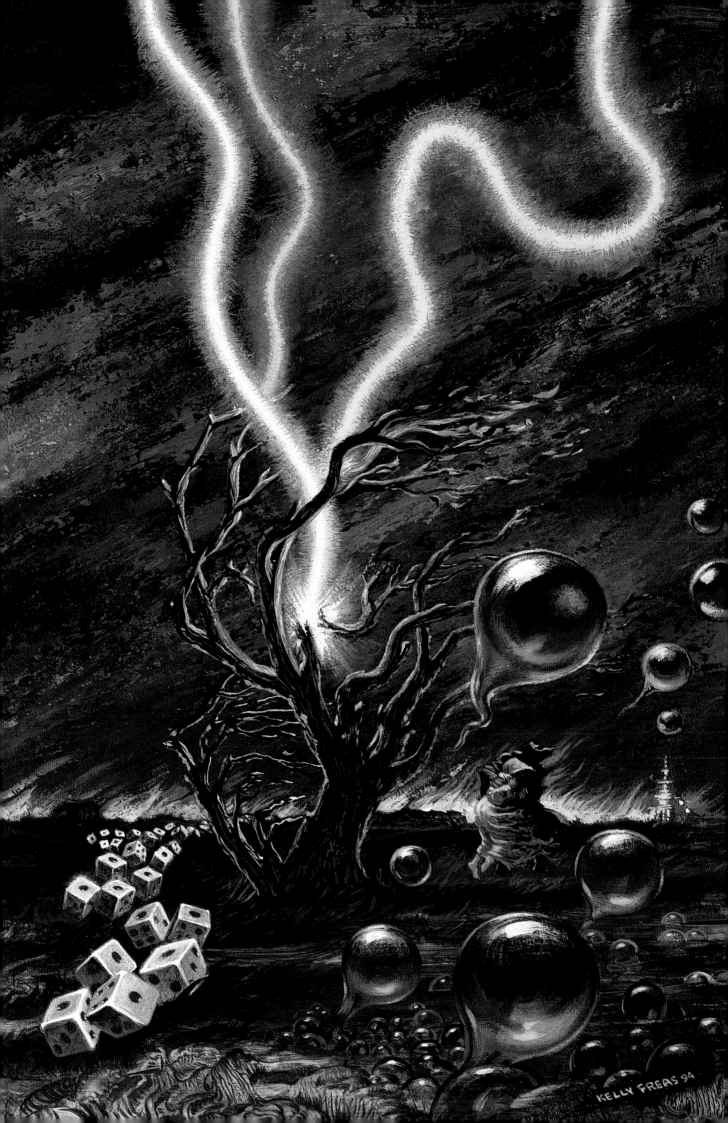

perceptions may have nothing to do with the external stimuli. (Think about this the next time you feel like strangling your boss, your customer, or your spouse.) *Meaning* is always projected from your mind.

I don't want to bore you with technicalities. The library offers plenty of basic research you can interpret for yourselves. I want simply to skim the surface of one of the most basic reactions of the human perceptual matrix: your sense of colour.

Most of our reaction to colour is unconscious: we perceive it but we don't *observe* it. Try looking at a white cloth, a white vase, a white statue. Notice how the lighter shades may take on the blue of the sky, in which case the shadows will show warm browns and oranges, with maybe some green reflections from grass or trees.

Or, the same white cloth – you *know* it's white, don't you? – may have intense yellow lights and deep purple shadows because of bright indoor bulbs. What colour *is* the cloth? What do you mean by '*is*'? What is the illusion: what you know you see, or what you think you know? And are you quite certain you know what you are seeing – or that what you see is what is there?

Well, we may not be able to penetrate the illusion, but we *do* know there is some sort of reality out there, especially when we bang our shins on it. And we can become aware of the illusion, even sometimes make use of it, instead of being used *by* it.

The day after the first caveman discovered that a burnt stick would leave interesting marks on the rocks, some joker came along with a handful of leaves and berries to fill in all the open spaces with colours. Both Ug and Zug were disgusted when, after a few days, the pretty reds and greens turned to dirty brown. Then and there began the search for bright and long-lasting pigments.

The first useful pigments were earth colours – reds, yellows and browns. If you have ever worked or lived in an area of red loess, you'll know exactly how the idea arose: once that dust gets into anything, it *stays*. The same is true, if less obvious, for the various yellows. Burned bone makes a great black which mixes readily with the yellows to produce a whole range of interesting greens. Blue was somewhat more difficult, which is one reason turquoise still retains some value. Usable blues came much later. The cave painters' palette was limited, but they did have some permanent colours.

By the time we got around to clothing and cosmetics, a lot of people were interested in the problem. There was a shellfish in the eastern end of the Mediterranean: it gave a beautiful purple dye, and it *stayed* purple, unlike that North African rock that made such a beautiful orange solution, but turned muddy grey in a week or two.

There were many dyes that were barely adequate for fabric. One was called Dutch pink. It was made from buckthorn berries, and the colour was lovely, though unfortunately very fugitive. There was vermilion – a name which covers a multitude – but in this case refers to the intense, brilliant mercuric sulphide. This was the heaviest pigment ever discovered; unfortunately, it was as erratic as its users. Frequently it would turn black for no discoverable reason. Nowadays, of course, we use the stable and exquisite cadmium red – if we can afford it.

A few hundred years later some ingenious soul came along and invented water-soluble felt-tip markers that were instantly taken up by us artists. They are handy and fast and require no preparation, and the colours are simply superb. Unfortunately, they too fade – erratically but fast: in ten years (with luck; usually less) they leave us a black-and-white line drawing with a pale suggestion of the colour that once was. We haven't actually come full-circle, though – it only seems that way. There are plenty of good, permanent colours available. You can, if you shop carefully, buy a good steak, too . . .

Left:
Matter's End
Acrylics: 15in x 20in (38cm x 51cm)

Suspend the laws of chance – or merely modify them a bit – and the possibilities are unlimited. Or is that a tautology? Chaos seemed a little too busy for my purpose, so I settled on a few impossible possibilities: an endless row of snake eyes, lightning striking repeatedly in the same place, and a mudflat oozing balls of mud that rise like balloons. No doubt, to be consistent, the mudballs should all be different shapes.

Frontispiece, novel by Gregory Benford, Easton Press, 1994

Overleaf:
Pulsar
Acrylics: 20in x 15in (51cm x 38cm)

Put together a pulsar, a vagrant planetoid and a *curious* spaceship and there has to be a story somewhere. Actually, this all made for a good double-page spread for a story in *Analog*, expanding some of the material I did on the cover.

Interior, *Analog*, mid-December 1991, illustrating 'Try a Light Touch' by Robert R. Chase

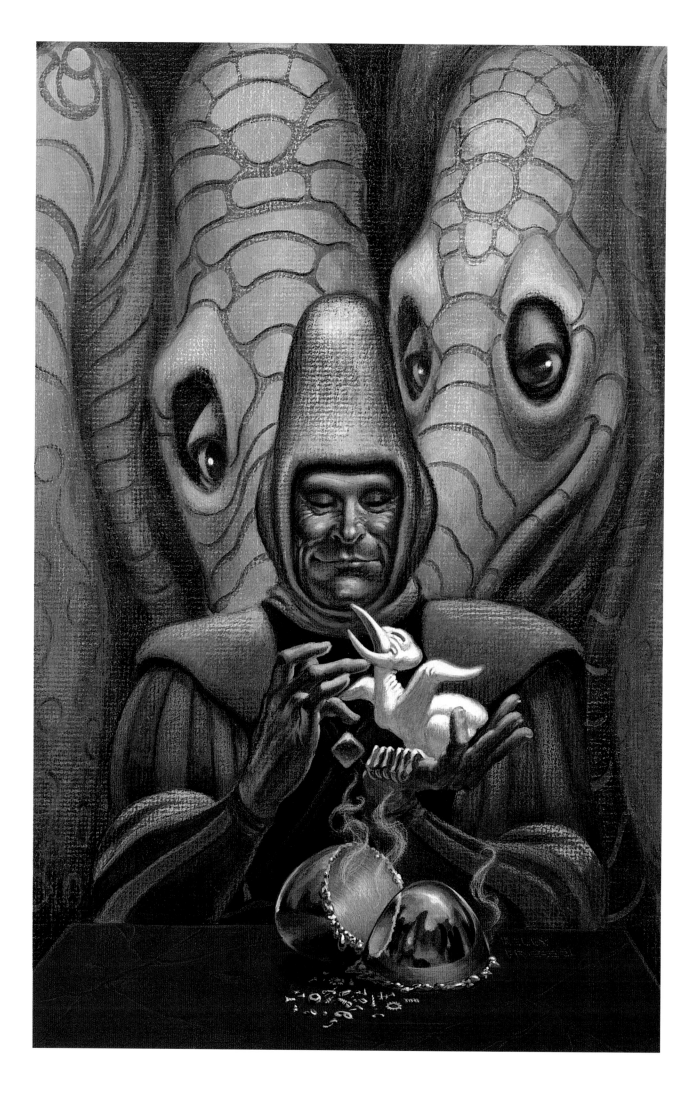

Colour in painting is one area where less is demonstrably more. The most brilliantly colourful paintings are not those in which the greatest variety of the most intense hues is used but those in which the most subtle neutralizations are used to build up to a feeling of intensity and brilliance.

There was a master of European-style buckeye art some years ago who painted endless scenes composed of a road in the foreground, a cottage with a lighted window in the middle distance (it was always twilight) and a gorgeous mountain peak in the background, still lit by the setting sun. The sunlight was so bright you felt like putting on sunglasses, and the combination of orange light and purple shadow made the very atmosphere vibrate with its intensity. Only there wasn't any purple or orange: the brightest hue in the whole sizzling mountain was a mixture of burnt sienna with a little white, and those lovely violet shadows were just a scumble of opaque white over a base of pure burnt sienna.

The answer lies in the ability of your eye to adapt to the ambient light – and the willingness of the idiot half of your brain to accept the eye's message as valid. In this case the whole canvas was done in grey tones, i.e. neutralized blues and violets into which the acclimatized eye could read endless subtleties of greens and browns and deep rusty reds. The sudden leap from the cool dark foreground colours to the hot light ones of the mountain was enough to convince the eye of an intensity of colour that was not actually there, but which the mind accepted as a valid extrapolation of similar views it had on file.

If the mountain *had* been painted in intense tints of orange and violet, the mind would have said, 'Yuck! Junky calendar art,' and the whole effect would have been lost. It may have been Austrian buckeye, but it was also a fine demonstration of the old saying that the best medium to mix your paints with is genius.

Left:
Arzach
Acrylics: 15in x 20in (38cm x 51cm)

Another occasion of high flattery was the invitation to do my version of Moebius's Arzach for a guest artists' portfolio. But Arzach takes a back seat to the little bird that has just beaten its way out of its stainless-steel egg.

Cover and interior, *The Arzach Legend Portfolio*, Starwatcher Graphics, 1992

Right:
Operation Luna
Acrylics: 15in x 20in (38cm x 51cm)

The further adventures of Katie Matusek, Captain, US Army Magical Corps, with her husband, a bobtailed werewolf. Originally done for Tor as a cover for Poul Anderson's novel, it remains unpublished.

Unpublished, 1999

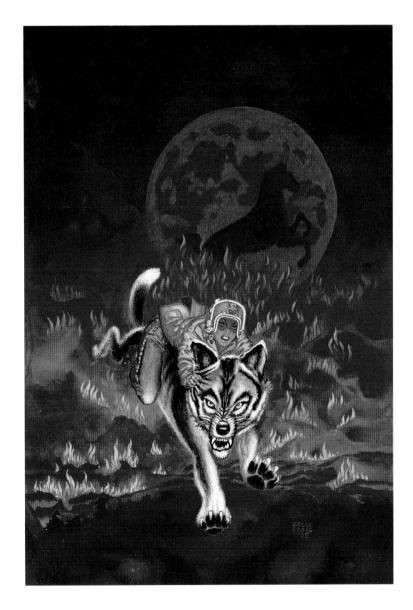

A case of alternate corporeality: when the man is in human form, the woman is his blade, and vice versa. They are in fact brother and sister, the victims of a cruel spell.

Cover, *Marion Zimmer Bradley's Fantasy Magazine* #13, 1991, illustrating the story by eluki bes shahar

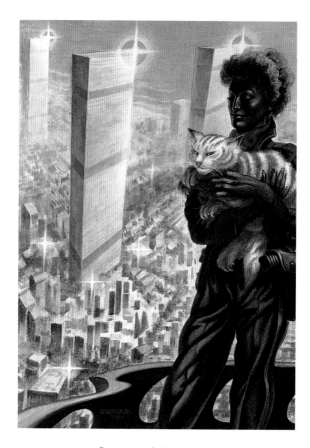

Queen of Angels
Acrylics and Prismacolor Pencil: 11in x 14in (28cm x 36cm)

Appropriately enough, this was my first cover assignment when I left the restrained psychosis of the East Coast for the unbridled madness of the West. Trying to visualize the look of a crowded ground level from the building's balcony five hundred feet up, I used a map as my reference. That did not solve the problem of the fog coming in over Santa Monica at 4:00pm: how much of the coast and the bay would you see? The obvious solution to this problem could have been a typical jazzy rockabillygo-go portrait of a city, all in primary colours, but I felt there'd been too many of those already. And there were enough action scenes in the book to fill a dozen comic books. The black heroine was fascinating, as was her red-and-white-striped kitty, but I reluctantly subordinated her to the image of the city from one of its towers. Not too much, though: she was the lead character, after all. The general scheme was worked out from a city map; I assumed that even The Big One wouldn't too greatly change the topography of Los Angeles, and that rebuilding would largely follow the same lines.

So, viewpoint a few hundred feet above Century City, looking toward the ocean at about Santa Monica Pier. Simple enough, hm? I wasn't sure . . . There are a lot of hills in between, and I didn't know the area well enough to guess at it. Obviously the long shadows of sundown would bring out the contours of both land and buildings.

Off we went to Santa Monica Airport to hire a helicopter. The pilot was delighted with the sketched idea, and was superbly cooperative. Armed with my 35mm camera, we made a couple of sweeps to determine our best viewpoint. We had to work fast before the sun set and the light faded.

I then sent Laura up another five hundred feet with the Polaroid, just in case. She's still griping about having to dangle from a flimsy seatbelt over a 1500ft column of air while simultaneously focusing, snapping and trying to keep from littering the LA landscape with Polaroid scrap. One minor factor: as the sunset fog rolled in, it obscured all the distant detail. The pictures came out looking exactly like the roughs I had done from the map – before I blew all that money for a chopper.

Frontispiece, novel by Greg Bear, Easton Press, August 1990

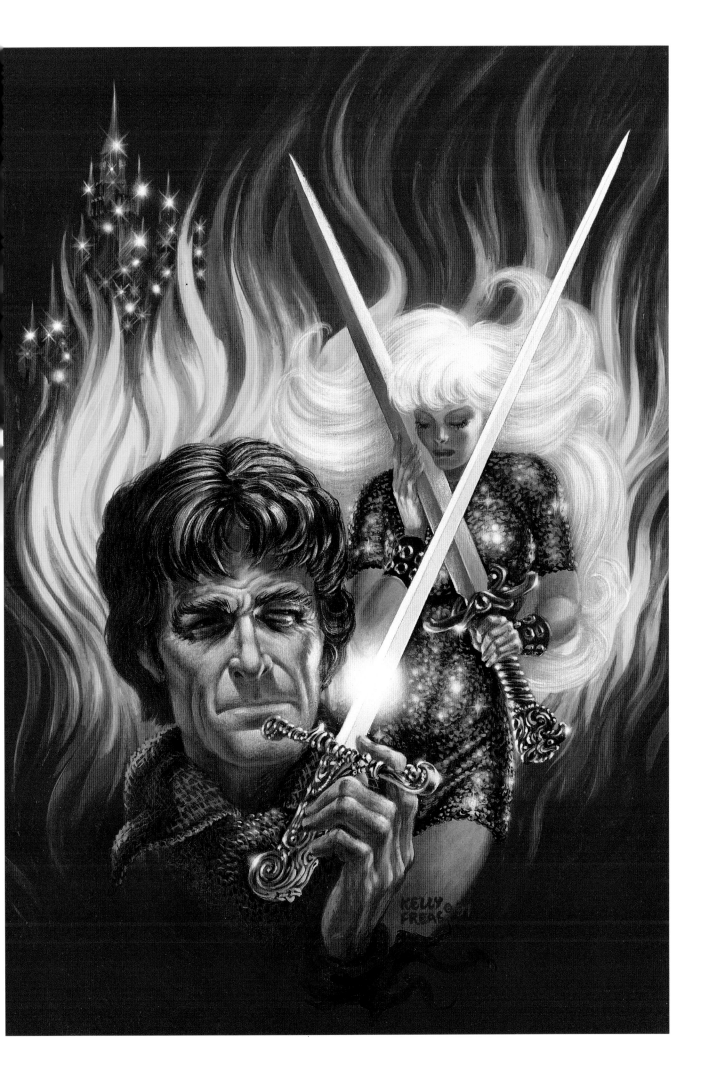

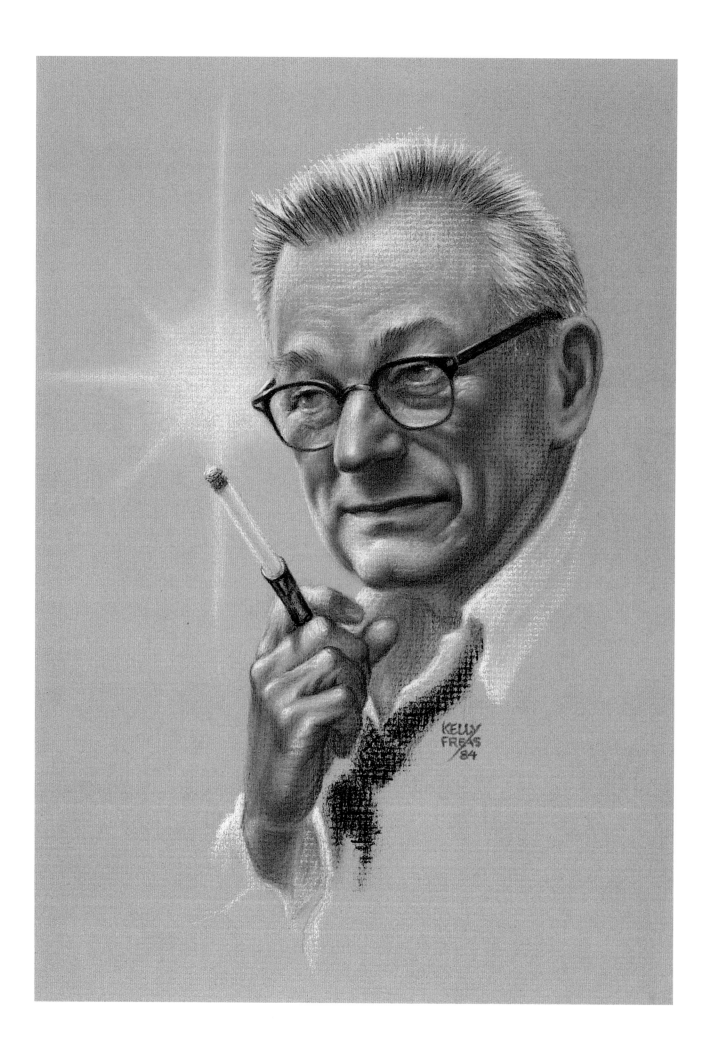

Some of My Best Critics Are Friends – or Vice Versa

CRITICISM – of painting, music, cinema, books – is a fine art in itself, of course, and as such it has a very highly organized set of rules, techniques, methods and subtleties fascinating both to the professional critic and to the dilettante who merely likes to know a little bit about everything.

To we who suffer under the critic's lash, or are carried triumphantly into the sunset on his shoulders, the set of rules for the critic is considerably simpler.

First, does he understand what I have tried to do in this particular painting?

Second, does he know enough about my subject and my methods to be able to decide whether or not I have succeeded?

Third, does it make any difference to me what he thinks?

If the critic does not understand me, my subject, my approach to it, or the immediate problem I have set myself in any given painting, obviously he cannot know whether or not the painting was a success in *my* terms. And, if the critic's opinion doesn't in some way help or hinder my pursuit of whatever my goals are, it's not likely to interest me a great deal.

Meeting these criteria – taken strictly from the viewpoint of the professional producer of whatever art we are considering (in this case painting, to keep it simple) – does not get the critic entirely off the hook, however.

For the artist, one of the critic's prime functions is not only to judge whether the artist

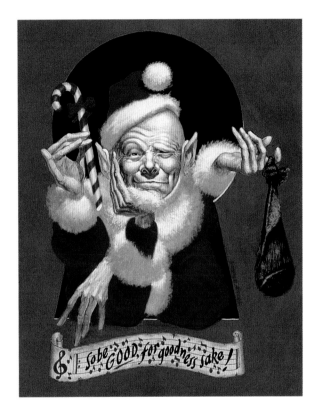

Above:
So Be *Good*, for Goodness' Sake
Acrylics: 15in x 20in (38cm x 51cm)

Done for *Galaxy*'s Christmas issue, 1994, with my own Little Green Man standing in for their traditional four-armed Santa Claus. Obviously he doesn't expect anyone to be good, but he's prepared. Tradition says that good children get candy and bad children get a few lumps of coal. In a sock, yet? And you can guess how it will be delivered!

Cover, *Galaxy*, November/December 1994

Left:
John W. Campbell, Ed.
Acrylics: 15in x 20in (38cm x 51cm)

Campbell was a large platinum god to me years before I met him, and, with all our disagreements, differences of opinion and arguments, one would never have expected us to become best friends. But we did. John enjoyed arguments. My portrait of him probably has more of my being in it than his, but it certainly shows how I felt about him.

Cover, *The John W. Campbell Letters*, edited by Perry A. Chapdelaine Sr, Tony Chapdelaine and George Hay, limited edition, AC Projects, 1985

solved the problem he set for himself but also, and even more important, to be able to consider whether the problem was worth solving at all, and how this artist's personal solution relates to those of other artists who have approached the same problem. Obviously this is a difficult area of judgement. It requires a great deal of background knowledge, and usually needs some first-hand experience with the artist's medium of expression. It also requires a rather broad

39

human experience, along with a perceptive, inquiring and sympathetic mind.

There are a few people who have all those qualifications, and it is no surprise to find that they are also rare and wonderful human beings.

There is another important type of critic who doesn't necessarily need any of the above qualifications, any more than all of the artists he reviews have to be Michelangelos or Picassos. Let me expand.

The critic is of paramount importance to the *consumer* – and this is not to be disregarded by any would-be self-supporting artist. All the consumer needs to know is that most of the time his own opinion coincides with that of the critic. Consider, for instance, movie reviews. You may be interested in a particular production's special effects, its cinematography, its dramatic level, its philosophy, etc. – but primarily you want to know if it's worth your time and money to go and *see* it.

You read the critic–reviewer – the distinction is real and important (critics get paid more), but in terms of everyday function it tends to get rather vague and hazy – with whom you most often agree, and decide on that basis. Of course, your favourite critic may not have covered this particular opus – so the next best bet is the reverse. We all know reviewers who love things we despise and can't stand others that delight us. All we need to know is that our critic is dependable, which means consistent. (Except for Willem von Grooge: he never likes *anything*. We just read him for fun.)

The ideal critic–reviewer is one who guesses right, for *you*, at least three-quarters of the time, on the simple basis of will you or won't you like this picture. But he does a lot more. He leads you into any number of bypaths: little oddments of fact that add to your understanding, snippets of perception

Men and Axe
Pen and ink on board: approx 8½in x 11in (22cm x 28cm)

Publication history lost

which call your attention to elements you might have missed, hints of value judgments which make you think a bit more about things you previously took for granted. And, as you learn to respect his opinion, you often find that the very things on which you disagree open new avenues for exploration and enjoyment.

If I seem to be excessively gentle with critics – who do, after all, have a rather unsavoury reputation (second only to the artists themselves) – it may be because I have over the years gotten such good treatment from them. Once upon a time there was a critic who couldn't tolerate me at all . . . he died. There are a few others who haven't yet; but I have every intention of outliving, outproducing and outshouting them. Note to potential critics: be warned!

41

Left:
Campbell's World
Acrylics: 15in x 20in (38cm x 51cm)

Yes, it's a portrait of editor John W. Campbell Jr – with cigarette holder and overflowing ashtray, as well as a mop of dark hair that John never had. In this alternate world it is not John but mythologist *Joseph* Campbell who works for *Astounding Stories of Science Fiction*, and his experience is more with magical symbols than technological ones.

Colour interior for 'Campbell's World' by Paul Di Filippo, *Amazing Stories*, September 1993

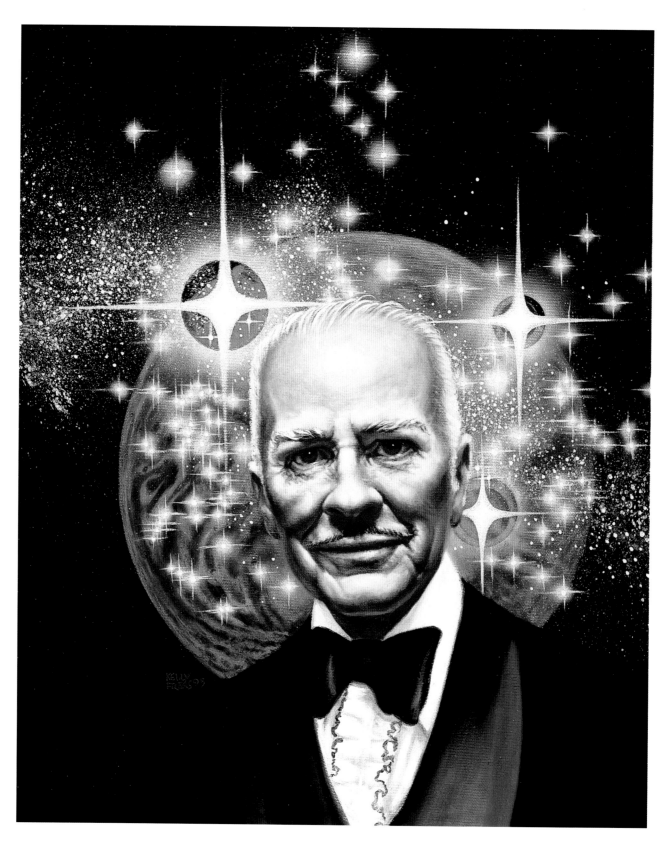

Above:
Robert A. Heinlein
Acrylics: 15in x 20in (38cm x 51cm)

A rare opportunity to capture the likeness of this great writer, also my friend, showing the potency of his mature years. There is a print of this painting in a Heinlein Library in Butler, Missouri.

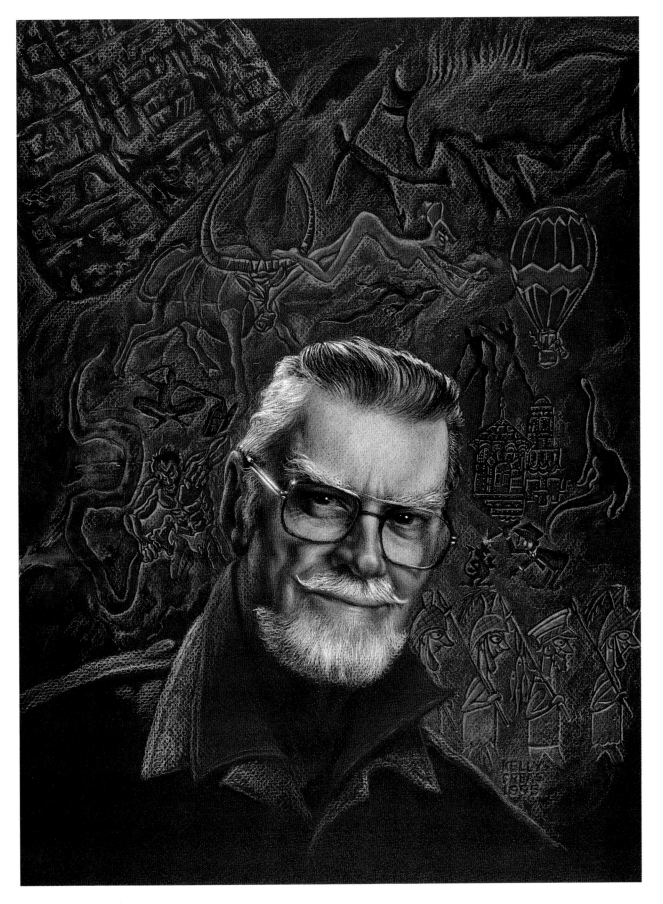

Above:
L. Sprague de Camp
Acrylics: 15in x 20in (38cm x 51cm)

What a face for a portrait! And with all those stories of Sprague's – he's an archaeologist, among other things – to be carved into the walls. It was painted for a cover, but the de Camps liked it so well they bought the original. Now that's appreciation.

Cover, *Time and Chance: The Autobiography of L. Sprague de Camp*, Donald M. Grant, 1996

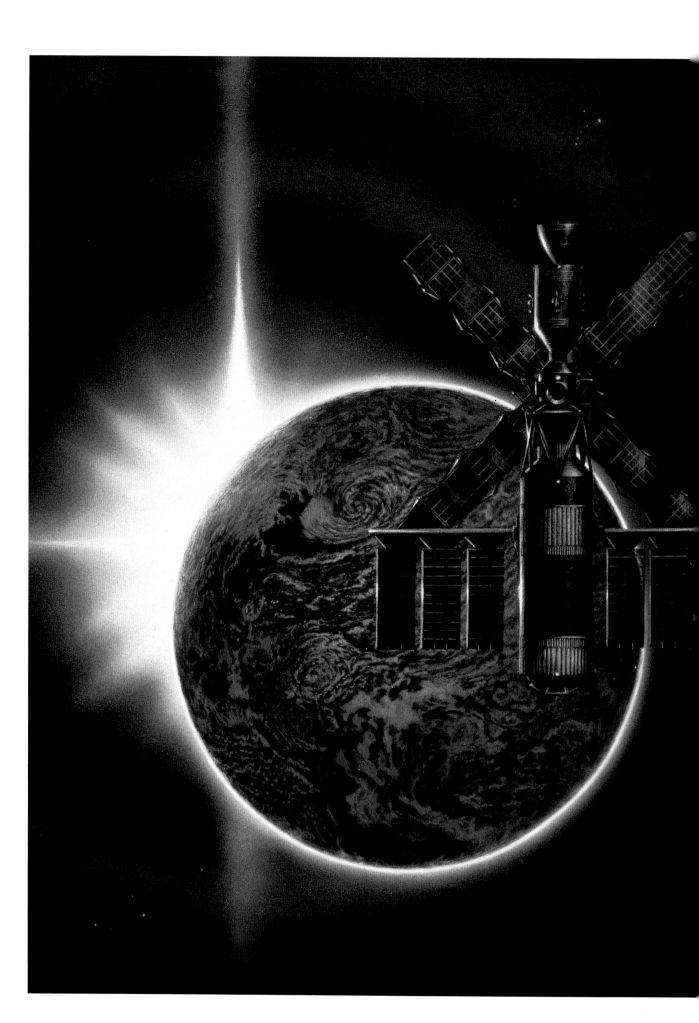

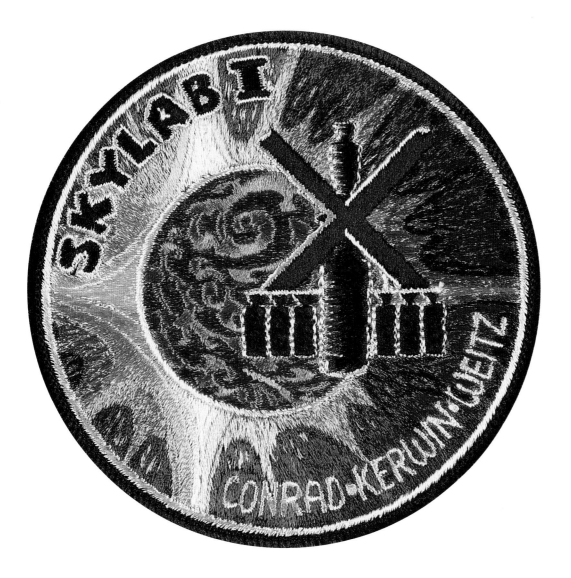

Above:
Skylab Patch
Machine-embroidered fabric: 3¾in (9.5cm) diameter

Probably any artist in the country would have been flattered to be asked to design a shoulder patch for the crew of Skylab 1. I certainly was. This patch, which actually flew in space, was given to me by the astronauts. The design was inspired by the silhouette of Skylab seen from directly above: as Nordic runes it reads 'father', 'mother', 'family of man'.
Curious coincidence, eh?

National Aeronautics and Space Administration, 1971

Left:
Skylab Painting
Acrylics: 15in x 20in (38cm x 51cm)

For the issue in which they published my article about the Skylab patch, the folk at *Analog* wanted the original painting I'd done for the patch as the cover illustration. Problem: I didn't *have* an original – I'd designed the patch straight onto an embroidery machine. I had to start again, and my efforts resulted in the creation of a much more dramatic image.

Cover, *Analog*, June 1973, illustrating the essay 'Into the Future' by Frank Kelly Freas

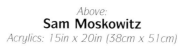

Above:
Sam Moskowitz
Acrylics: 15in x 20in (38cm x 51cm)

I did several variations before settling on a background for this memorial portrait of Sam, one of my oldest and most vocal fans, and a huge collector of science-fiction art. It was commissioned for the special edition of Sothebys' *The Sam Moskowitz Collection of Science Fiction* catalogue. Sam's widow, Christine, was given the original painting as a gift for her help in putting together the auction. This is my tribute to Sam as I remember him.

Tipped-in print, *The Sam Moskowitz Collection of Science Fiction*, signed and numbered auction catalogue, Sothebys, June 29 1999

Right:
Time Keeper
Acrylics: 15in x 20in (38cm x 51cm)

With appropriate changes – more hair, a more noble jaw, a more generous nose and a moustache I wished I had – the model was me. But a reader sent me a letter inquiring where in the world I had seen her husband. She enclosed his photograph. He *was* a ringer for the man in the picture – and was even posed in front of his collection of clocks!

Cover, *Magazine of Fantasy & Science Fiction*, January 1990, illustrating the story by John Morressy

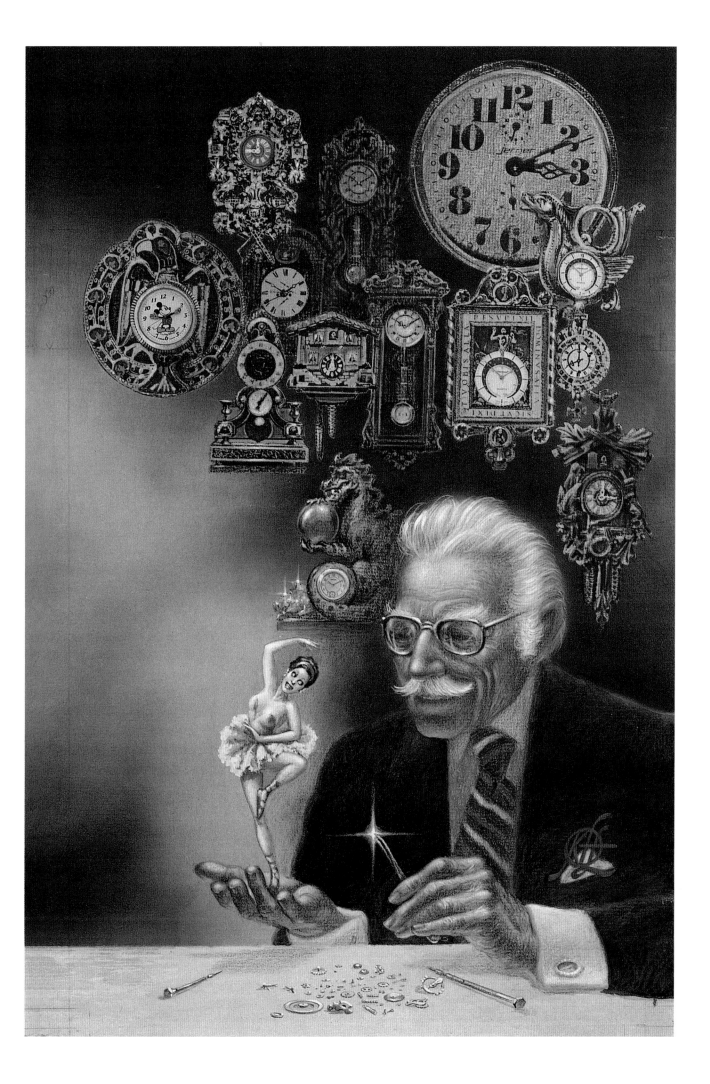

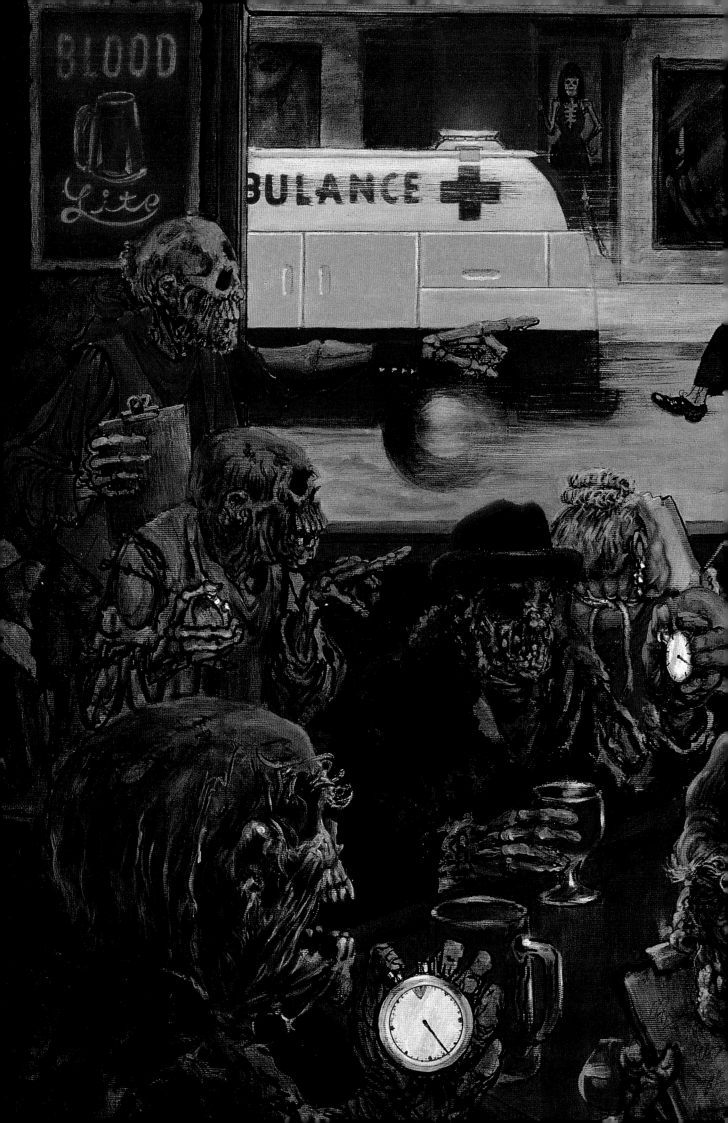

I Don't Know What's Good But...

THE AVERAGE ART BUYER, private or professional, knows as much about art as he knows about predicting the stock market – or a bit less. This is not entirely a disadvantage. What I mean is that there are some really knowledgeable people out there, who can give you a lot of valuable information and guidance if you seem to be worth the effort. And it means that there are also some people out there who will buy *anything* – including the rubbish the turkey at the next easel paints . . .

In art, as in most fields (with the possible exception of law, medicine and politics), the status of 'professional' implies a certain level of competence in its practice. Unfortunately, even a high level of competence in painting is no assurance that you're worth a damn as a professional artist or illustrator.

Have you ever heard of a plumber so enthralled with the intricacies of your septic tank that he reduced your bill by half? Or of a carpenter who put gables on his customer's house just because he liked doing gables? Not only do artists frequently do exactly that, but many art buyers actually expect it. 'Art for art's sake' is as much a con, long perpetrated by artists, as it is a common if somewhat feeble-minded philosophy.

If I sometimes seem unduly hard on art buyers, it doesn't mean that I consider artists a great deal better. In fact, like some engineers and most doctors, artists tend to know even less than most people about matters outside their profession; and

Left:
Dinosaur Beach
Acrylics: 15in x 20in (38cm x 51cm)

Too many things were happening on Dinosaur Beach for one image to do it justice. I chose to produce a somewhat surrealistic composite. The expression of bored disinterest on the dinosaur (pure fantasy) was merely a happy accident. The presence of a clock and clock parts was not – it's a time-travel thing. Painted with acrylics laid on opaque and quite heavy, the original has a nice golden glow – another happy accident.

Cover, novel by Keith Laumer, DAW, 1973

Preceding pages:
Bar Exam
Acrylics: 20in x 15in (51cm x 38cm)

The only living person is the galloping lawyer, although the animated corpses show considerable individuality. Note the organized-crime boss – with bulletholes in his cashmere coat.

Limited-edition print, Phantomb Publishing Company, 1995

51

Right:
Sam Boone's Appeal to Common Scents
Pen and ink on two-ply board:
20in x 15in (51cm x 38cm)

Interior, *Analog*, July 1996, illustrating the story by Bud Sparhawk.

their knowledge of art itself is all too frequently restricted to knowing what they like to do and how they want to do it. The illustrator often escapes this particular problem, which is basically one of egotism. He finds out quite early on that the broader his information base, the less time he has to spend researching an assignment. As a result the illustrator tends to acquire a wide-ranging and intensive, if rather informal, education.

Aesthetically, it's not much help. Artists are universally noted for their execrable taste. I think the most likely reason for this is a tendency to find beauty in the most improbable things – which is itself a result of the artist's natural dissociation of visual stimuli from their verbal or emotional implications. A Philip Danforth Armour and a Rembrandt van Rijn both take delight in the sight of a fine side of beef, but for vastly different reasons. Even in his immediate concern – the painting – the artist usually is more concerned with avoiding 'taste' as thrust upon him by his education, his culture, his customers and his current girlfriend than he is with developing his own.

I used to be notable for my neckties: seldom discreet, they were almost always memorable. I chose them because they entertained *me*. But fathers pointed them out to their sons as examples of what to avoid . . . Over the years, my drawing and painting have certainly improved, but I'm not so sure about my neckties.

Right:
Dying Inside
Acrylics: 20in x 30in (51cm x 76cm)

The main character's telepathic reception is fading. He can no longer amuse himself by tuning in on women's intimate moments, or support himself with inside market information. As his telepathy is his only talent, time is running out for him.

Frontispiece, novel by Robert Silverberg, Easton Press, 1991

Overleaf:
Monoclonal Antibodies I
Acrylics: 24in x 36in (61cm x 92cm)

Larger (24in x 36in) than usual, this medical illustration shows the fleet of tiny cancer-killers attacking diseased cells, bypassing healthy body parts to reach their organ-specific destination.

Cover and print, *Third International Conference on Monoclonal Antibody Immunoconjugates for Cancer*, University of California San Diego Cancer Center, 1988

Above:
Genetic Profile
Acrylics: 15in x 20in (38cm x 51cm)

Insurance actuarial tables will become a whole new ballgame when DNA becomes
a predicting variable.

Interior illustration for 'DNA Determines Insurance Risk', *New Jersey
Business Journal*, 1993

Right:
The Left Hand of Darkness
Acrylics: 15in x 20in (38cm x 51cm)

There's amazingly little action in this most cerebral story, I discovered on rereading it.
A snow scene was mandatory, but the implied menace is dual: note that the
foreground snow cliff can be read as either a roaring head or a crouching monster.

Frontispiece, novel by Ursula K. Le Guin, Easton Press, 1992

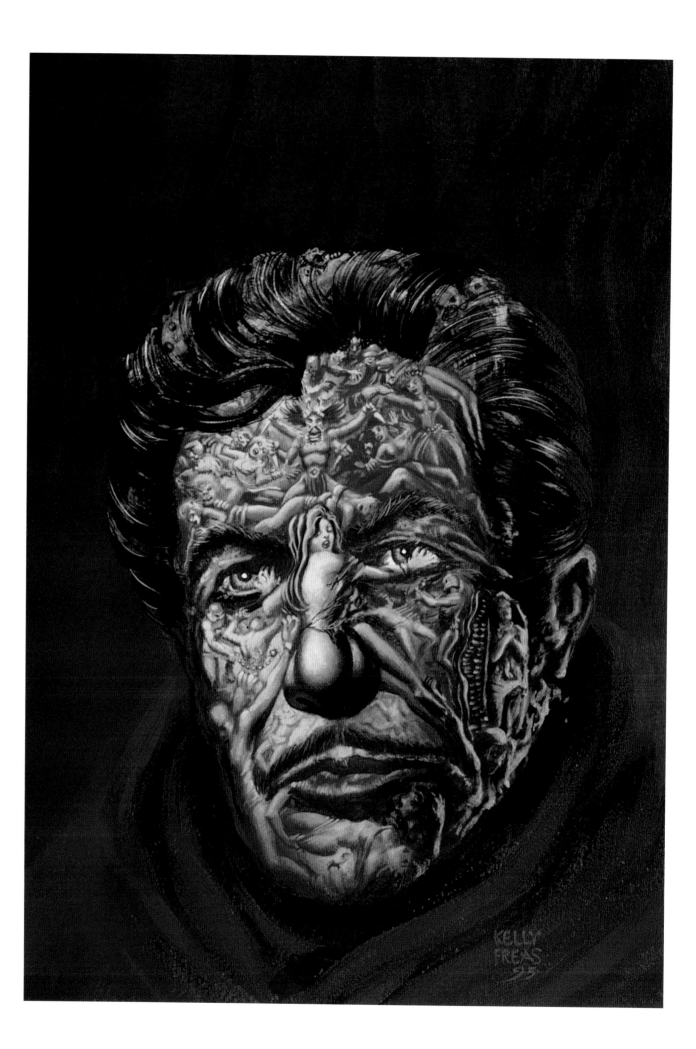

In Defence of de Philistines

For the creative person in – and, let us not forget, a product of – a commercial culture, life can be made much less frustrating by consideration of certain characteristics of that culture. To lump them all together as Philistinism is tempting, but not productive of either accomplishment or understanding.

It is easy to put down commercialism or, for our purposes, business. Nevertheless, a moment's reflection will make it clear that the commercial philosophy of business has made possible the very basics of our modern world, and much of what we find desirable in it. Democracy, economic as well as political, has been nourished and developed as a direct result of the commercial philosophy that free choice in a free market, with free movement of people, goods and money, equals profits. Education facilitates democracy, creates a more useful workforce, broadens the economic base and increases the range of needs and desires – all of which equals profits. Education both requires and facilitates communication. Communication creates not only a market in itself, but also many

Above right:
Alfie and the Little Green Man
Acrylics: 15in x 20in (38cm x 51cm)

A private commission, done like most such to the buyer's specifications. The spaceship is simply the rocket from a Hugo Award, with slightly elaborated fins. And don't ask how Alfie got that helmet on over his head . . .

Private Commission, 1997

Left:
Vincent Price
Acrylics: 15in x 20in (38cm x 51cm)

An assignment for the obituary issue of *Famous Monsters of Filmland* became my homage to the great Vincent Price. Some 47 figures in torment make up his features. I almost went on to give more space to the *Masque of the Red Death* costume, but fortunately good sense prevailed.

Cover, *Famous Monsters of Filmland*, Fall 1993

more new markets, as producers and consumers alike become aware of new areas of production and consumption.

The interlocking network of politics, economics, education and communication, with its spin-offs of household and leisure activities, health and fitness and entertainment, becomes constantly more finely tuned and closely meshed. And it is against this background that the contemporary artist (in whatever field or medium) must function – or fail.

We might say that the foundation of commercialism is acquisitiveness – certainly human wants are as basic as breathing or any other natural function, although that takes us back thousands of years more than we need to go. And acquisitiveness is as virtually synonymous with Philistinism as is utter lack of taste or selectivity. However, while medieval courts and Renaissance palaces gave considerable expression to the acquisitive tendencies of the upper classes, they didn't effectively touch the lower. Further, the expression of wealth and power was limited quite considerably to

59

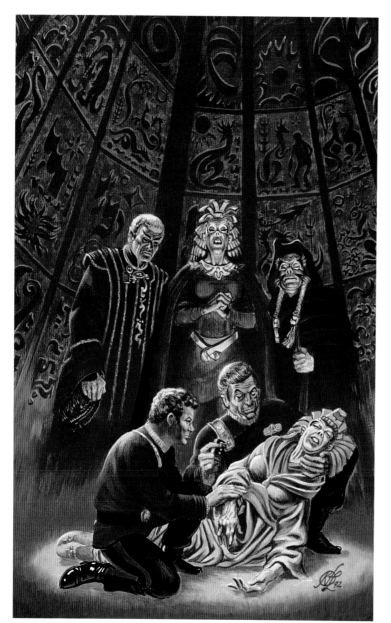

Left:
Star Trek Annual
Acrylics: 15in x 20in (38cm x 51cm)

The client was entirely reasonable. His provider was not. The materials, and especially the authorizations, were not given to us until about 36 hours before the work was due. So, with Laura working upside-down from the top, and me working on the figures from the bottom, we finished – seamlessly – at about 4:30am and shipped it off as soon as it got light. Interesting specification for the wall inscriptions: 'They should be a cross between Japanese and Jewish.' Leave it to my wife to figure it out.

Cover, *Star Trek Annual*, Marvel Comics, March 1992

Right:
Famous Monsters of Filmland World Convention Poster
Acrylics: 20in x 30in (51cm x 76cm)

Crystal City was host to this con. It will probably recover. Forrest J. Ackerman had seen my painting *Scribe* (see page 92) and decided it would offer a great layout for his *FMOF* poster, with all the monsters – fully rendered this time – supplanting the imps and demons in the former version. I'm told the poster has become a collectors' item.

Poster, *Famous Monsters of Filmland* World Convention, Crystal City, Virginia, May 1993

aesthetic matters: beauty, in short. Beautiful castles, grounds, horses, carriages, books, paintings, clothes, jewellery – all with direct reference to the taste of the nearest potentate – were the expression of the nobility. Thus the very vice of acquisitiveness provided the milieu for developing and employing artists . . .

It took several hundred years for enough regular income to fritter down from the aristocracy for the average man to have beauty in his personal environment – and employ *us*. The results are obvious.

For all of this, then, let us be duly grateful.

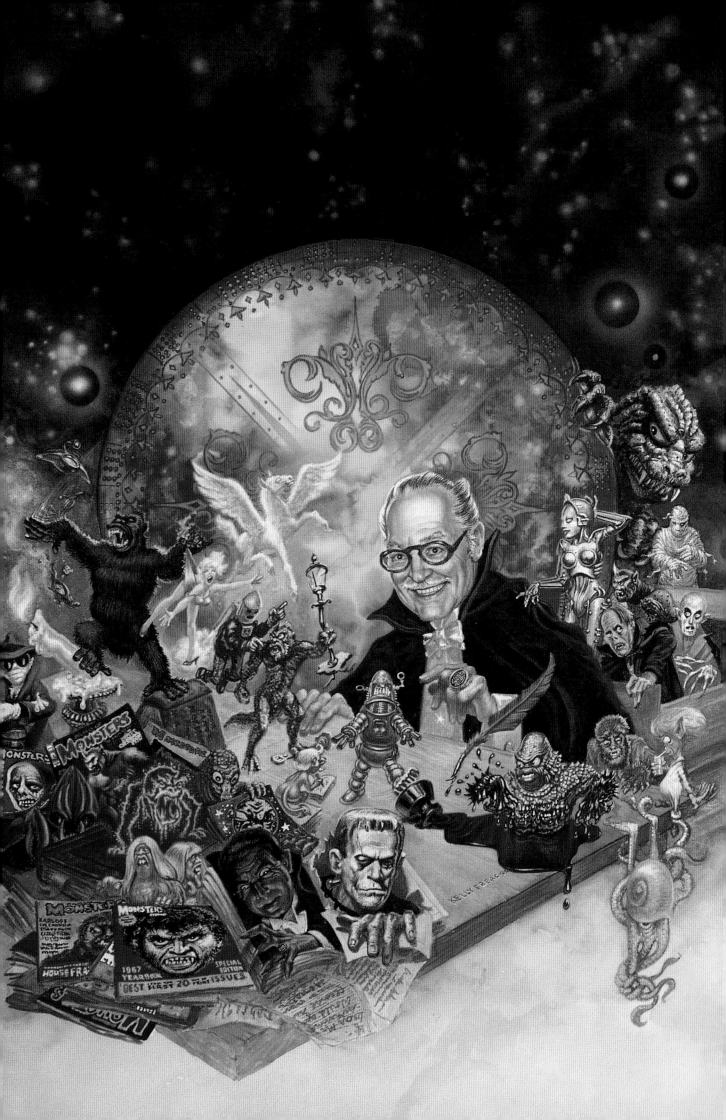

Above:
Quaddie
Acrylics: 15in x 20in (38cm x 51cm)

Bred for a gravity-free environment, the Quaddie has an extra set of arms growing where her legs would ordinarily have been. Definitely a useful feature in null gravity, as well as for playing this two-sided, double-stringed dulcimer.

Cover, *Analog*, August 1989, illustrating 'Labyrinth' by Lois McMaster Bujold

Above:
Rosemary's Baby
Acrylics: 15in x 20in (38cm x 51cm)

Another picture that virtually painted itself. The grey metal thing in the foreground is a witch-ball.
Around it you'll see crumbs and shreds of the herbs (devil's fungus) that fill it. The most fun in this one
was the transparent cellophane in the box.

Frontispiece, novel by Ira Levin, Easton Press, 1994

Overleaf:
Intergalactic Hockey
Acrylics: 20in x 15in (51cm x 38cm)

This was a convention programme-book cover, the puck being the convention's logo. The players' equipment
suggests that space hockey games are a tad rougher than even our own. Not a lick of paint in the entire paint-
ing: I used the new coloured gesso (a surface preparation medium) and Prismacolor pencils. The idea for the
picture and initial layout was Laura's (a tie-in to the hometown's sport's frenzy), hence the 'KFL' signature.

Artist Guest of Honour cover for programme book, Context Science Fiction Convention,
Edmonton, Alberta, Canada, 1991

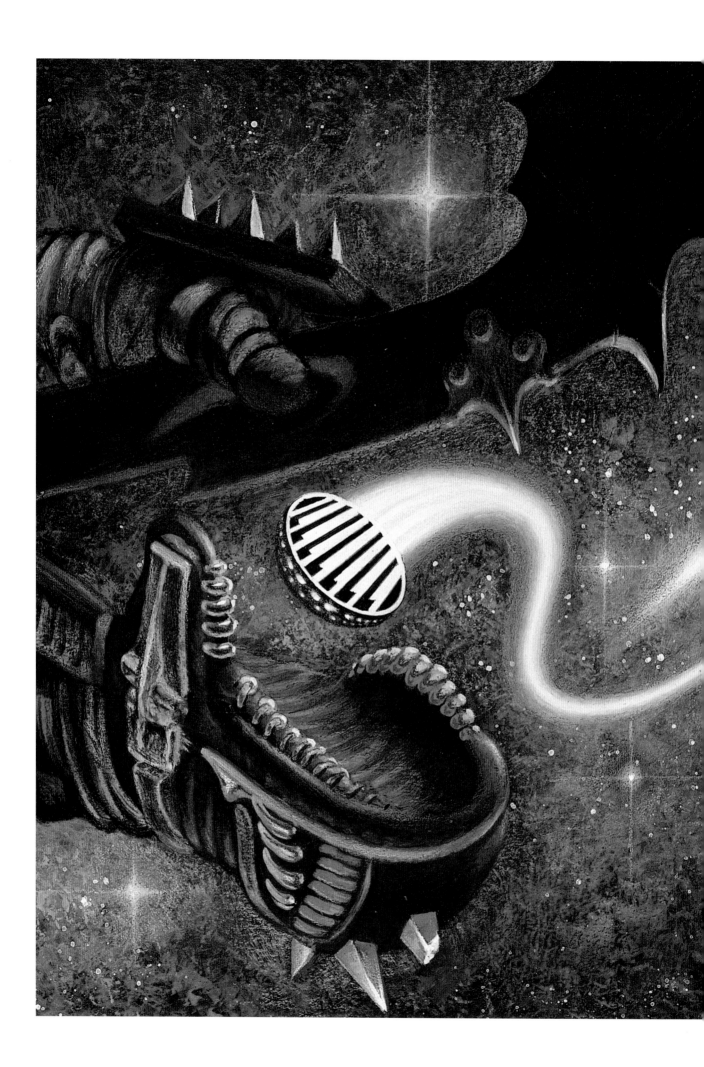

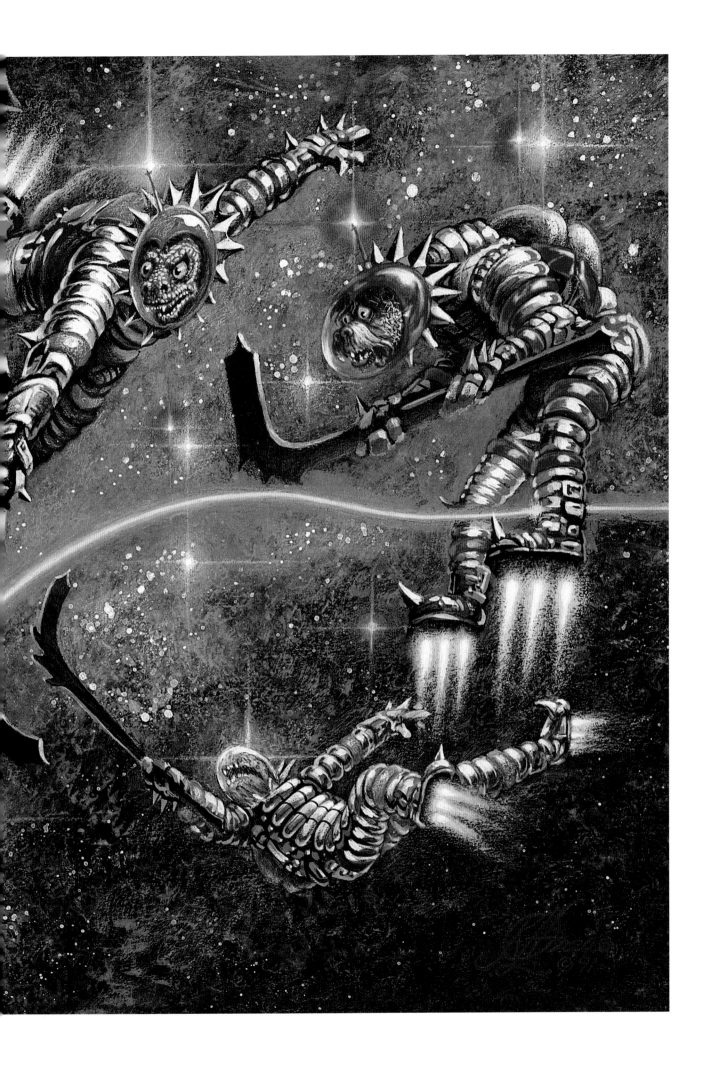

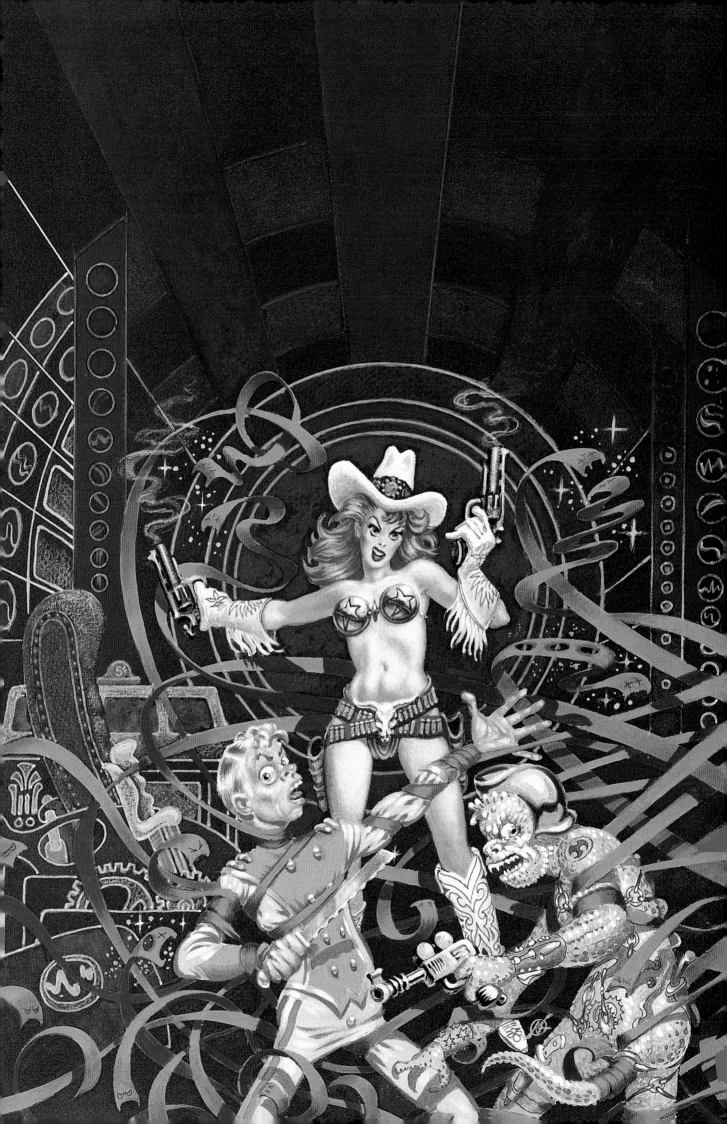

Selling Books

Everyone knows that pretty girls sell books – and virtually anything else you can think of. Less well known is the fact that a pretty girl sells the product just as well to other women as to men. Women buy more pictures of babies than men do, but the number of men who react positively to soft cuddly animals is almost statistically identical to that of women. And a *colour* picture (of almost any situation) featuring your product sells better than any number of words.

A survey some years ago revealed the fact that books with yellow covers outsold those of any other colour. Frankly, I'm not convinced that you couldn't cook up a survey to demonstrate practically anything you chose to prove. For a while, however, one of my clients insisted that even deep-space scenes be painted yellow. Evidently a lot of publishers agreed, because for a few months everything on the news stands was predominantly yellow. Then some hustler with a little imagination and a voice loud enough to shout down the opposition issued a block of four novels: one dark blue, one deep maroon, one emerald green and one black (with white and fluorescent red type). He swept the market, naturally. His books stood out as if all the others had been especially designed as a background for them.

Today it's hard to convince some circulation managers that space scenes don't *have* to have black backgrounds – but I can assure you that no cover you see on a book is ever there just because it's a pretty picture. It's there because the publisher believed that it would motivate you to reach out and pick the book up. If the average buyer picks up a book, there is about a 70 per cent chance that he will buy it.

I'm not sure that this applies to science-fiction fans. I swear I have watched while a fan picked up a book, studied the cover for five minutes, read two or three pages, went back to the cover for another careful study, said, 'Grrrrumph!' and put it gently down again.

Left:
The Red Tape War
Acrylics: 15in x 20in (38cm x 51cm)

Red tape is the least of our hero's problems, since he is about to be shot by his *alter ego*. As if that curvy cowgirl with her six-guns a-blazin' weren't trouble enough.

Cover, novel by Jack L. Chalker, Mike Resnick and George Alec Effinger, Tor, 1991

Above:
Victorian Space Girl
Pen and ink on one-ply illustration board: 9in x 12in (23cm x 30cm)

Bookplate. Conduit SF Convention, 1993, Bride of Conduit, Salt Lake City, Utah

Then he picked up another and went through the same routine.

I figured that he could be dismissed simply as a statistical anomaly – until I caught myself doing exactly the same thing, and decided that he must have been a cover artist who had slipped his leash.

The result of all this is that a lot of artwork is done to a formula, sometimes an obvious one, sometimes not. But *all* covers are designed to stimulate the potential buyer's instinctive reactions and, above all, like a good stripper, to whet, not satisfy, his curiosity.

Let's try to visualize a cover for you, which might be painted to a formula designed entirely to appeal to the buyer's glands rather than his head. Obviously it will have a yellow background: bright sunny yellows through golden and greenish yellows to warm ochres and siennas. This establishes our positive attractions – at least theoretically.

Next we will put a large, darkish, menacing shape in the foreground. This gives contrast and tension. Naturally it will have some splashes of bilious green and livid purples (lovely word, 'livid'; it took me years to find out what it meant, but it sounds so *nasty*) and a few smears of smoky reds.

In the middle distance, near centre, we'll put a pale pink blonde (note all that innocent helplessness with just two primary colours?), wearing a very brief red costume (we want

67

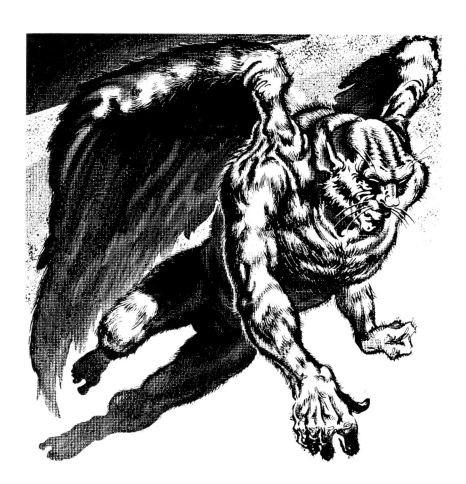

Right:
Mister Justice
Acrylics: 15in x 20in (38cm x 51cm)

I'm well aware that no camera lens would reflect a figure this way. Let's call it merely artistic licence – to let you know what the lens is looking at. For some reason, it's one of my all-time favourite covers. Obviously, if I understood the reason for its success, I'd be able to repeat it . . . so try, try again, Freas.

Cover, novel by Doris Piserchia, Ace, 1972

Left:
Flying Tiger
Ink on Canvo paper: 15in x 20in (38cm x 51cm)

Left half of a double-page spread for 'Gamma is Thee!' by Stanley Mullen, *Planet Stories*, July 1953

excitement and attention, and a very small red garment gets considerably more than the theory predicts). Her posture indicates fear and trembling. Now we have a focus for the viewer's attention, while stimulating both the sexual instinct and the protective instinct (that, too, works on both men and women!) and we have boosted the optical tension further by contrasting the delicate and sensuous curves of the figure with the pointy and angular massiveness of The Menace (whatever *that* is).

Some distance away, but not too far to relate closely, we'll put a male defender racing to the rescue. His blue shirt and his dark green trousers and his russet-brown boots relate to the natural good forces of the forest and sky – and he gives the potential buyer something to identify with. OK . . . some*one*.

Now, you'll note that I have said nothing about the story this atrocity is supposed to illustrate. The reason for this is the fact, demonstrated repeatedly by comparative sales figures, that the news stand buyer could not possibly care less. You care, I care, sometimes even the editor cares, but the man who ultimately pays the bills just doesn't give a damn.

This formula and its variations has sold hundreds of thousands of pulp magazines, and some slightly more sophisticated versions of it still sell thousands of comic books and romantic paperbacks. And need I point out the plague of its bastard offspring which can be seen nightly on TV and in every other cinema?

Science-fiction illustrators have never stopped trying to break out of the formula – or at least to bend it all out of shape, to give our viewers something to think about as well as something that they will react to. Once in a while we get away with it – usually when working with a strong and, let us say, idiosyncratic editor. When fighting City Hall, it helps to have company. Fighting the physical, optical and psychological laws that govern the human reaction to colour, shape and form, and the combination thereof, is a different matter. It is a losing battle, because you are not a mere formula. You can't escape from them and do anything effective, because they get their force from your very blood and bones and glands – not from your intellect. The intellectual – even the aesthetic – stimulation is pretty much the frosting on the cake, but that frosting is what keeps us doing space art instead of something that makes money.

Now you know all the tricks we use on our book covers in our never-ending effort to part you from your lunch money. Next time you look at a painting, science fiction or otherwise, try standing

aside enough to observe your own reactions. Don't take anything you see at face value. You may still be manipulated – if the artist has been successful, you are sure to be, one way or another – but at least you will know how, why, and by whom.

And you'll have a lot more fun looking at pictures!

Below:
Animal Farm
Acrylics: 15in x 20in (38cm x 51cm)

I purposefully kept away from a literal use of Communist symbology, which would have been not only obvious, but also rather dull. I focused on Napoleon and, instead of a hammer and sickle, gave him a mallet and scythe – not to mention a yoke and a whip.

Frontispiece, novel by George Orwell, Easton Press, 1992

Right:
Nineteen Eighty-four
Acrylics: 15in x 20in (38cm x 51cm)

A close look will reveal that the faces of Winston Smith and Big Brother are identical – not only to each other but to mine as well, since I used myself as the model. (Laura and I use each other as models for illustrations a lot, by the way: we're cheap and we're handy.) The spots of glowing red represent the eyes of giant, horrifying rats – the rats of Winston's imagination.

Frontispiece, novel by George Orwell, Easton Press, 1992

70

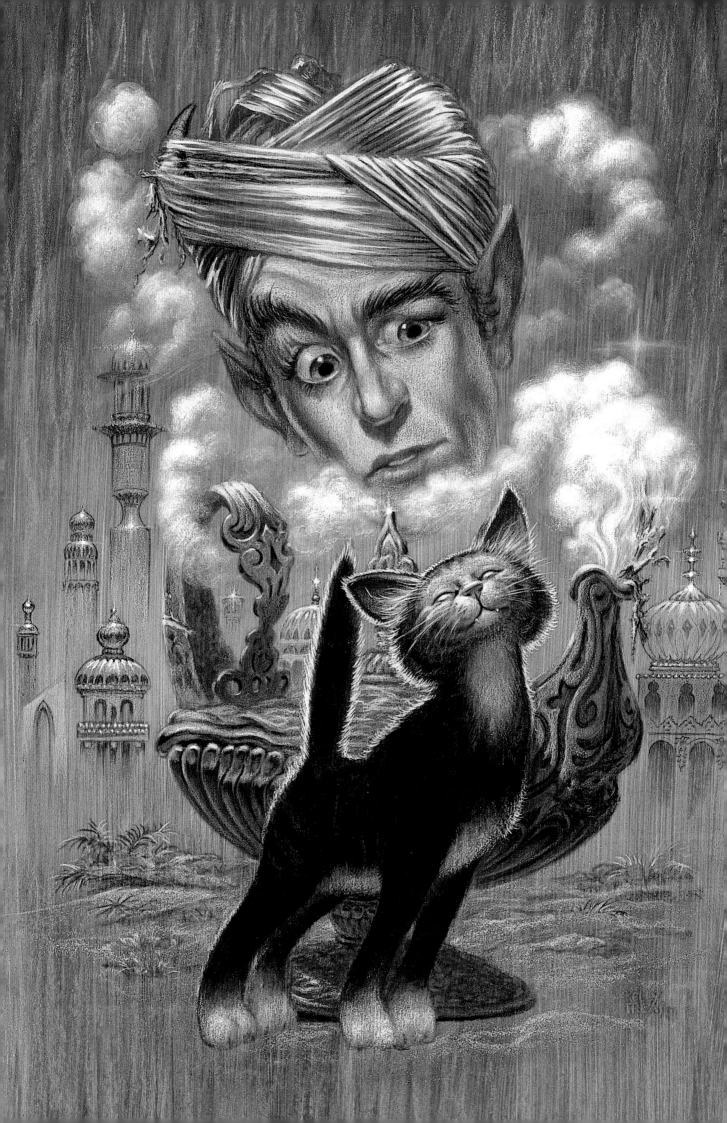

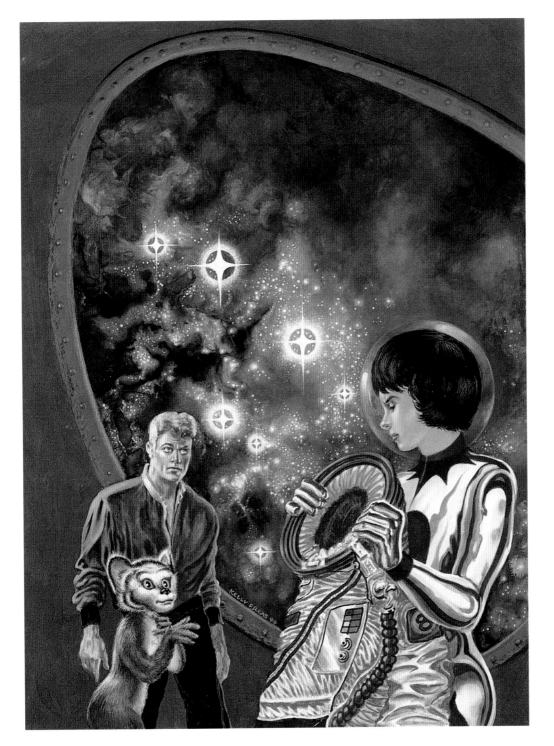

Above:
Have Space Suit – Will Travel
Acrylics: 15in x 20in (38cm x 51cm)

Doing a cover for a Heinlein story is always a pleasure, not least because of Heinlein's subtle humour.
I attempted in this one to add my own touch with the hero's little friend, the Mother Thing. It seems
to be asking whether it gets a space suit, too, or whether it's supposed to squeeze in with Kip.

Cover, novel by Robert A. Heinlein, Science Fiction Book Club, 1994

Left:
The Wishing Season
Acrylics: 15in x 20in (38cm x 51cm)

I loved this story, like most stories about cats. This one would never have got off the ground but for the
kitten snuggling up to the lamp. The genie slept through the lecture on Humans 101, so can be forgiven for
his surprise at how small, furry and four-legged they are. The first one to rub his lamp is entitled to three
wishes. Kitty gets his three – and so the story begins.

Cover, novel by Esther Friesner, Atheneum, 1993

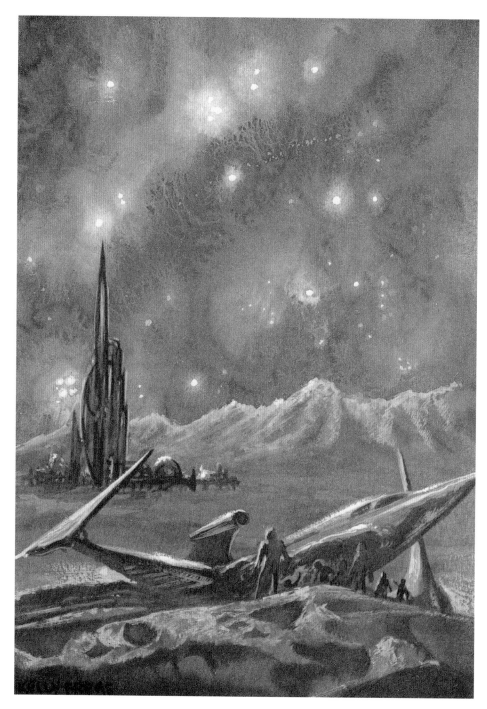

Above:
Cold Crash
Acrylics: 15in x 20in (38cm x 51cm)

A picture without a story is a rare thing. I love this picture, but it never got off the ground. If I could write, I'd do a story about it myself. It would probably deal with the crash of a trans-Arctic plane near an alien spaceship. The crew of the latter, of course, take the Arctic temperatures as too warm for comfort, and are looking for an air-conditioner repair man . . . Wrong muse, I guess.

Unpublished, 1965

Right:
The Hawks of Arcturus
Acrylics: 15in x 20in (38cm x 51cm)

My deceased wife, Polly, constructed and posed in the silver suit. The latter left home about the same time as my daughter did. I wonder . . .

Cover, novel by Cecil Snyder III, DAW, 1974

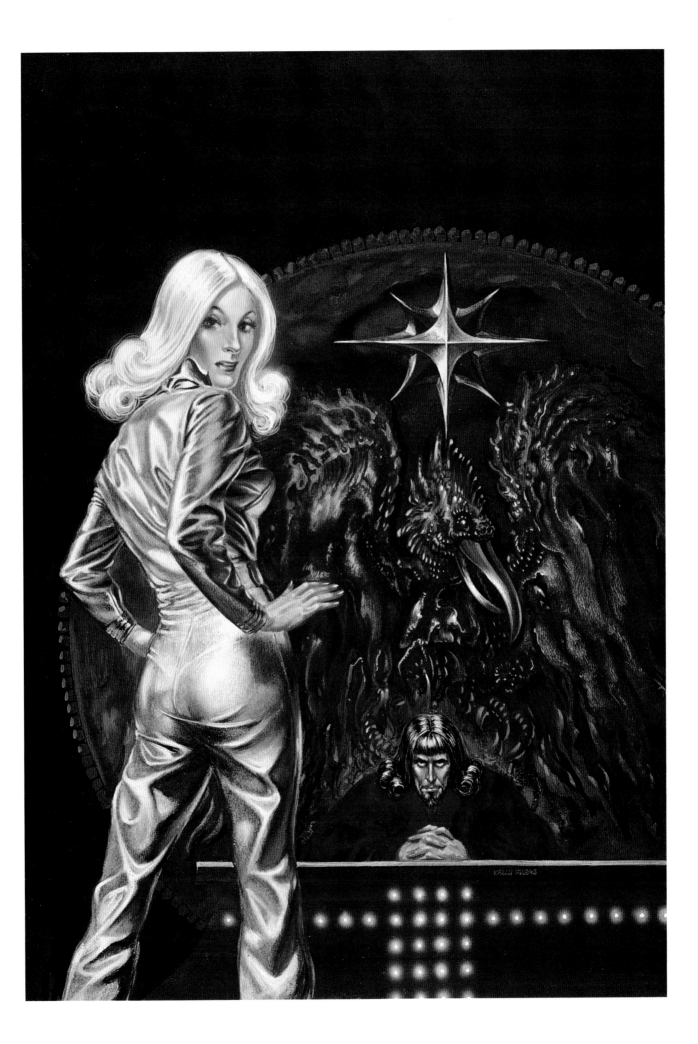

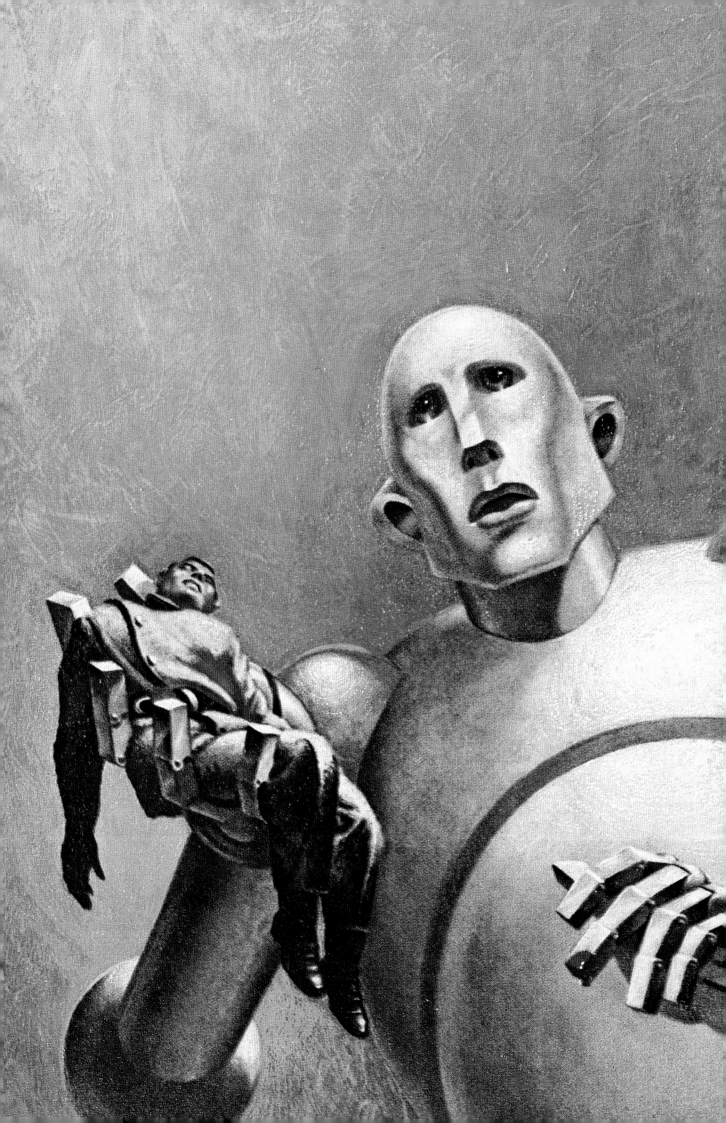

Robots and More Robots

THE PROBLEM of the artificial human – the robot – is one that has fascinated mankind since the first artist fashioned his first fantasy doll, 25,000 years or so ago, and wished she would come to life. The interest never slackened during the intervening centuries. Every culture has its legends of ersatz humans or something similar, all hinting at a constant effort to produce a living person by mechanical or magical means – and usually with less than ideal results. Daedalus built his guardian for Minos, and both of them became mere fairy tales. Pygmalion chopped out his Galatea from a chunk of marble, and fell madly in love. Cadmus sowed a dragon's teeth and harvested soldiers.

The Middle Ages produced any number of magical synthetic humans, the best known being Prague's Golem. I suspect that almost as many Renaissance alchemists worked on artificial life as worked on the elixir.

Primitive man certainly made dolls of all shapes, sorts and sizes; and I doubt that a child ever existed who didn't wish that a favourite doll would come alive. There is a certain sneaky thrill in the idea of a private playmate you can simply pop back in its box when it's bedtime. Give Junior 10,000 years and a touch of mechanical genius and you have the Stepford Wives.

In the meantime . . .

Seventeenth- and eighteenth-century fascination with clockwork and intricate mechanical

Left:
The Gulf Between
Acrylics: 15in x 20in (38cm x 51cm)

This robot was originally painted as my first cover for John W. Campbell Jr's *Astounding Science Fiction*. He introduced it as 'a new cover, by a new artist, in a new style'. I never did figure out what he meant by the 'new style', but I was not at that point, so early in my career, about to argue – especially not with him. The story, *The Gulf Between* by Tom Godwin, was about the gulf between artificial and human intelligence. I set myself the problem of illustrating it with a very intelligent robot (note the eyes) saying, 'Please . . . fix it, Daddy?' A later version appeared on the cover of the 1977 Queen album *News of the World*.

Cover, *Analog*, October 1953, illustrating a story by Tom Godwin

Below:
Aquila: The Final Conflict
India ink and scratch tools on canvas board:
11in x 14in (28cm x 36cm)

Interior, *Analog*, May 1983, illustrating a story by Somtow Sucharitkul

gadgetry found expression in pedestrian novelties such as buckle guns, pistol swords and pocket watches six inches in diameter. An amazing variety of mechanical men and women of all shapes and sizes was also produced.

In the centuries following the Industrial Revolution, interest in a practical mechanical man never slackened. After all, factory workers were cheap enough, but they tended to be disagreeable and they did wear out fast. Slaves were a little better, but the initial cost was high, and, if you wanted to get any mileage out of them, the maintenance costs were terrific.

Frankenstein gave all man-created substitutes a bad name for a while, which Karel Čapek's invention of the term 'robot' in his play *R.U.R.* didn't do a great deal to improve. But the concept remained alive and well and living in America. By the 1940s most homes had their automatic furnace-feeder, the Iron Fireman (or equivalent), plus a host of his relatives. Another ten years or so and the robots were burning our meals and mangling our laundry. The 1960s found them running the trains, delivering the bombs and even feeding chickens. By the 1970s they had progressed to managing our football teams, ballsing up our charge accounts and misdirecting our mail.

The robot's talents are considerable already, and, if he doesn't look like Robbie or the Tin Woodman, it's only because he can't pull himself together. All the parts are there: it's simply more efficient to have his brain in the office while his hands are in the mine shaft. And we don't talk about robots: we talk about computers, and smart bombs, and automated factories.

It may be a commentary on our culture that the nearest approach to a humanoid robot has been in the entertainment field, specifically the superb animated figures of Disneyland and its clones. At the same time, computer experts and psychologists argue about whether whatever it is that a computer does can be called thinking. And, if it isn't, what do humans do when *they* are thinking that the computer doesn't? The argument is hot as yet only in technical circles, but even the fringes are beginning to thaw.

One day soon, some gadgeteer with both the money and the knowhow will put together *her* version of a Stepford Wife and leave *it* to divert her absent-minded husband while she heads for Nassau with her self-programmed, self-repairing Friendly Local Auto Mechanic.

Or maybe she'll make her own FLAM: it might even be more useful.

And the point will be made: the dybukks are coming.

That is the real gulf between human and machine intelligence: the robot is *built* to serve man – man has to *learn* to do so. Only *there* is the secret of survival in, and access to, the Universe.

Right:
The Heart of the Enemy
Acrylics: 15in x 20in (38cm x 51cm)

It's hard sometimes to find adequate reference material. Where to look for a rear view of a skeletal pegasoid? How are the cervical vertebrae inserted in the back of the skull? Don't bother: if anyone has a complaint about the picture's accuracy, let him *prove* it.

Cover, game module by Dick Swan, Advanced Dungeons & Dragons, second edition, *Spelljammer* series, TSR, 1992

Overleaf:
Medea
Acrylics: 20in x 15in (51cm x 38cm)

A visualization created from several verbal descriptions: a map rather than a composition. We have an alien planet, an intelligent alien and a human attempting communication. At least a dozen different stories were developed from this picture.

Fold-out print, *Harlan's World*, anthology edited by Harlan Ellison, Phantasia Press, 1985

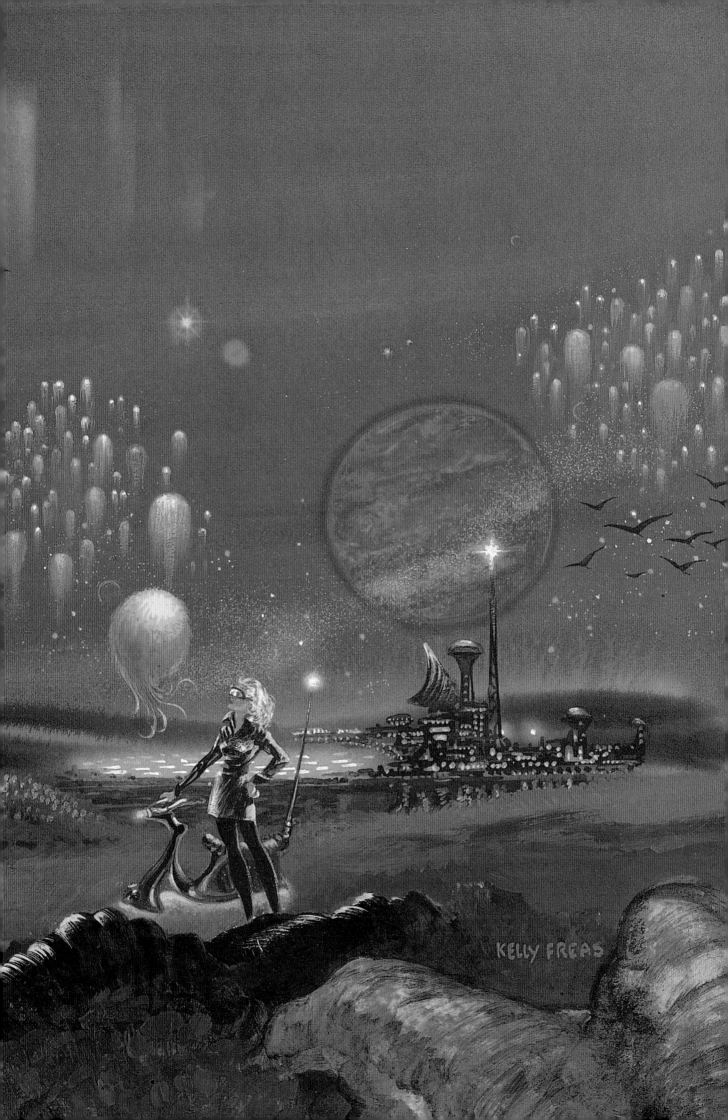

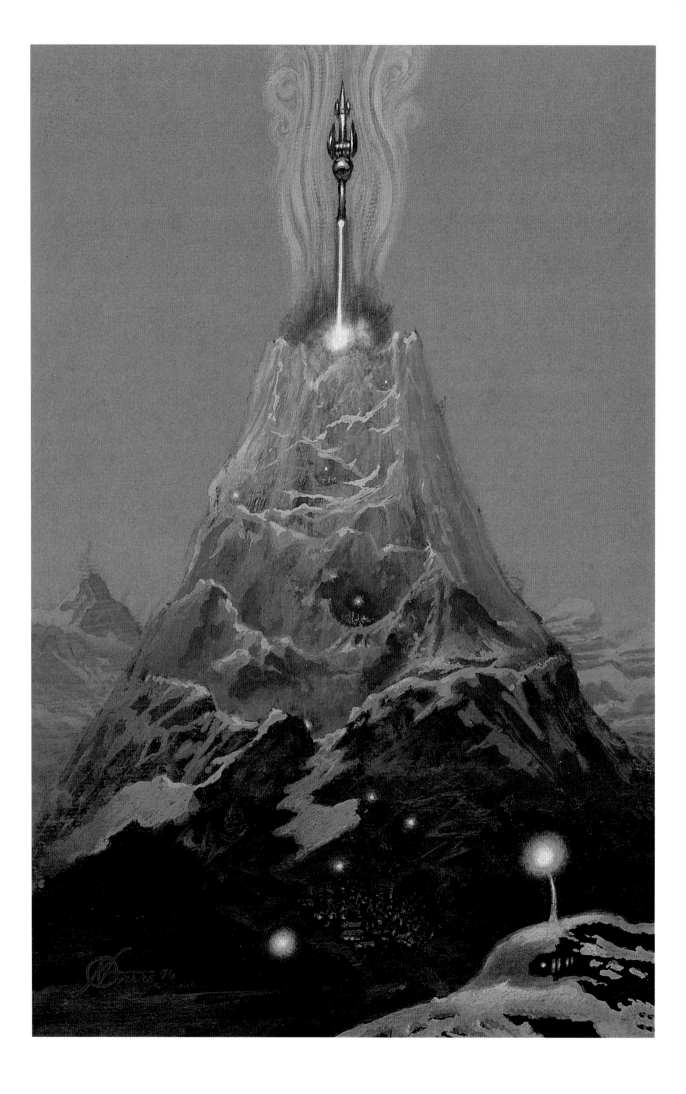

What, Art? What Art?

ERTAINLY THERE IS LITTLE in the total spectrum of human activity which our particular culture regards as less important, on any conscious level, than art: the first cut in any budget – private, corporate or governmental – is invariably the pittance it spends on art *qua* art. (Art for advertising is something else: *that* budget gets cut second.) Nevertheless, on the level we might call the 'cultural unconscious', art of one sort or another – art of which we are, generally speaking, consciously unaware – continues to saturate our environment and exercise its power. The movers and manipulators have always been aware of that power. Back in 1847, at a time when all advertising was restricted to single columns of agate type (agate has capitals about $\frac{1}{16}$ in high – it is just barely readable), James Gordon Bennett of the *New York Herald* would not allow use of any decorative stock cut, or even a two-line initial letter. The advertiser, he held, should gain his advantage from what was said, not from how it was printed. Most publishers of the day agreed with him: to attract attention by use of type or large display pictures was 'unfair' to the small-space advertisers. Since then, of course, times have changed . . .

Today, you are surrounded by art everywhere you go, whatever you do. Everything you buy or use at some point involves the talents of an artist or of several – some in its advertising, others in its packaging, some in the design of the actual product. I have an acquaintance, a winner of the Prix de Paris some years ago, who has become moderately wealthy as a designer of knobs for television sets.

The particular aspect of the art in our world which I want to talk about here is colour. Of course, colour is ubiquitous in our environment, whether natural or applied. For instance, contrary to the common opinion, you do not normally dream in black and white; you are simply so used to colour that you take it for granted. A dog sees the world in shades of grey; but we see in 'full-spectrum living colour', and dream the same way. (*Actually* dreaming in black and white is a first-order abstraction – the result of looking at photographs in newspapers and magazines, and watching old movies on TV.) We live in, and react to, a world of colour, and every bit of that colour has its effect on you, whether you know it or not – and even whether you are aware of the colour or not.

Your multi-umptillionth great-grandma was a woods-dwelling, bug-nibbling, fruit-and-nut-eating forager. She needed good eyes and a fine sense of colour to find food for herself and her offspring; she also required the precise and subtle discrimination necessary to determine the exact state at

Left:
Cloud's Rider
Acrylics: 15in x 20in (38cm x 51cm)

On this planet of conical mountains, settlements are started by clipping off a mountain top for the first one, then gradually working down. Finally, the largest settlements are built in the otherwise inaccessible valleys.

Frontispiece, novel by C.J. Cherryh, Easton Press, 1995

Right:
Krishna
Acrylics: 15in x 20in (38cm x 51cm)

One would really never bet on a meat cleaver outfencing 39 inches of razor-sharp steel. But if you successfully impale your opponent's kidney, it isn't going to be much consolation to him that you've punctured him with only ten inches of shortsword . . .

Cover, game box, Steve Jackson Games, 1997

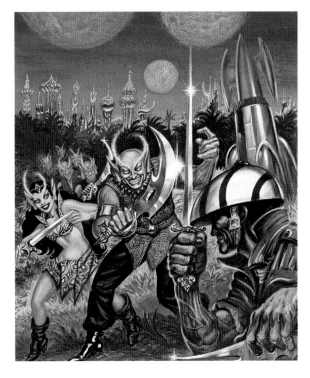

83

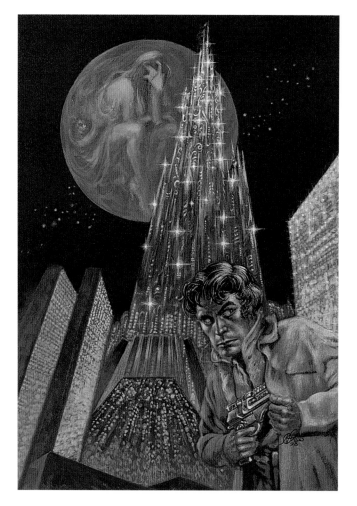

Above:
Slan
Acrylics: 15in x 20in (38cm x 51cm)

There's that gun again: I created it for James Schmitz's *The Custodian*. Ed Kline, model maker to the stars, crafted it in metal as a gift for me. Laura used it as a model for one of her illustrations for Le Guin's *The Left Hand of Darkness*; I thought it would be perfect for Jommy Cross. Believe me, with the mass of this thing, you could not fit it into a shoulder holster, but you could carry it (maybe not too comfortably) in your waistband.

Cover, audiotape version of the novel by A.E. Van Vogt, Ziggurat Productions, 1993

which a previously nourishing plant would become a noxious and unpalatable danger. You inherited her physical senses, and you also inherited her emotional reactions – along with many others added by succeeding generations. When we moved out of the forest onto the plains, visual skills became even more important.

At first glance it would seem that the profusion of colour and form in the forest would require greater visual acuity: to mistake an anaconda for a hanging vine or an alligator for a rotten log might terminate the incarnation quite suddenly. But there was equal danger – and opportunity – in the subtleties of form and colour on the sunburned plains: a deer or a lion can look embarrassingly like a half-buried rock when it tries to. Good vision

Right:
Jupiter Station
Acrylics: 15in x 20in (38cm x 51cm)

This was painted well before any colour photos of Jupiter were available. The colours of the planet turned out to be surprisingly close to the reality.

Cover for a novel (whose title and author I've unfortunately forgotten), DAW, 1985; also used as a cover for *Twilight Zone*, June 1988

was a survival characteristic, and our ancestors learned to use it well: those who didn't never became ancestors.

With several hundred – or several thousand – generations behind us, we regard ourselves as truly civilized. We have developed into intelligent, knowledgeable beings; rational creatures who take information from all our sensors, process it logically and act sensibly. Sometimes, anyway . . .

The fact is that, even for us, a good 75 per cent of our data input is visual, and every datum stirs up emotional echoes that rattle all the way back to the woods: a whole spectrum of them.

Take the warm, light colours. They make you feel good, optimistic, in tune with the world. These are oranges, golds, and hot pinks – all the colours loaded with the yellow of sunshine. Like the subtle greens of the spring meadow and forest, they are very effective for putting one into a pleasant and productive – not to mention reproductive – mood.

Below:
Serenissima
Pen and ink on two-ply board: 9in x 12in (23cm x 30cm)

Publication history lost

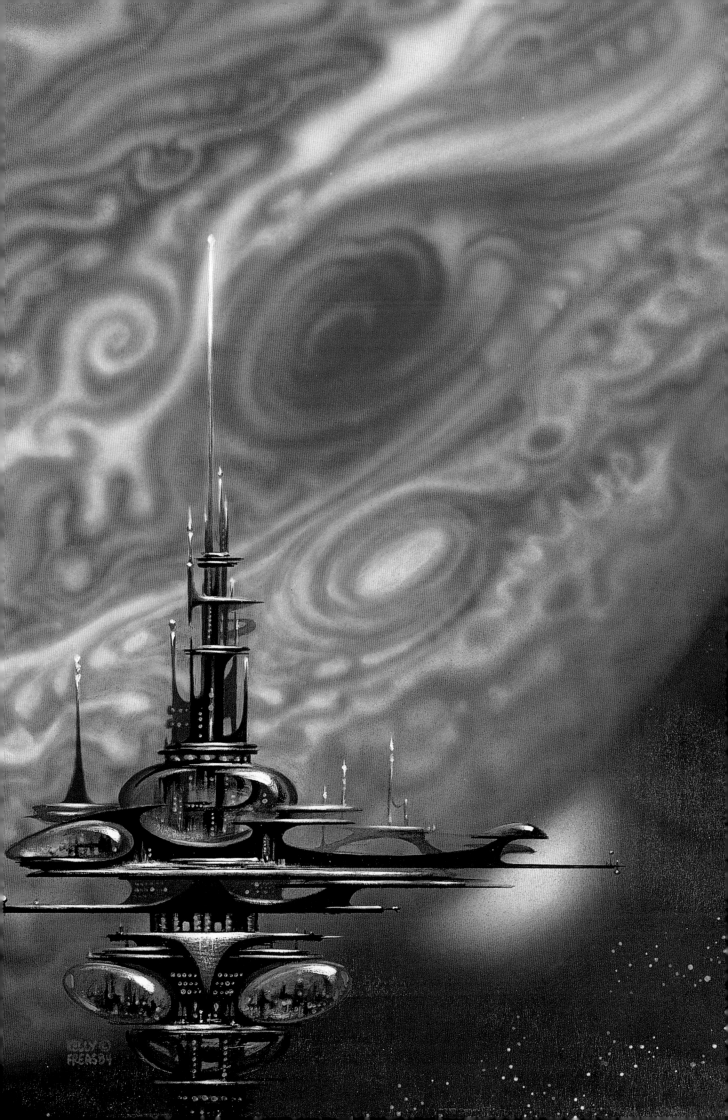

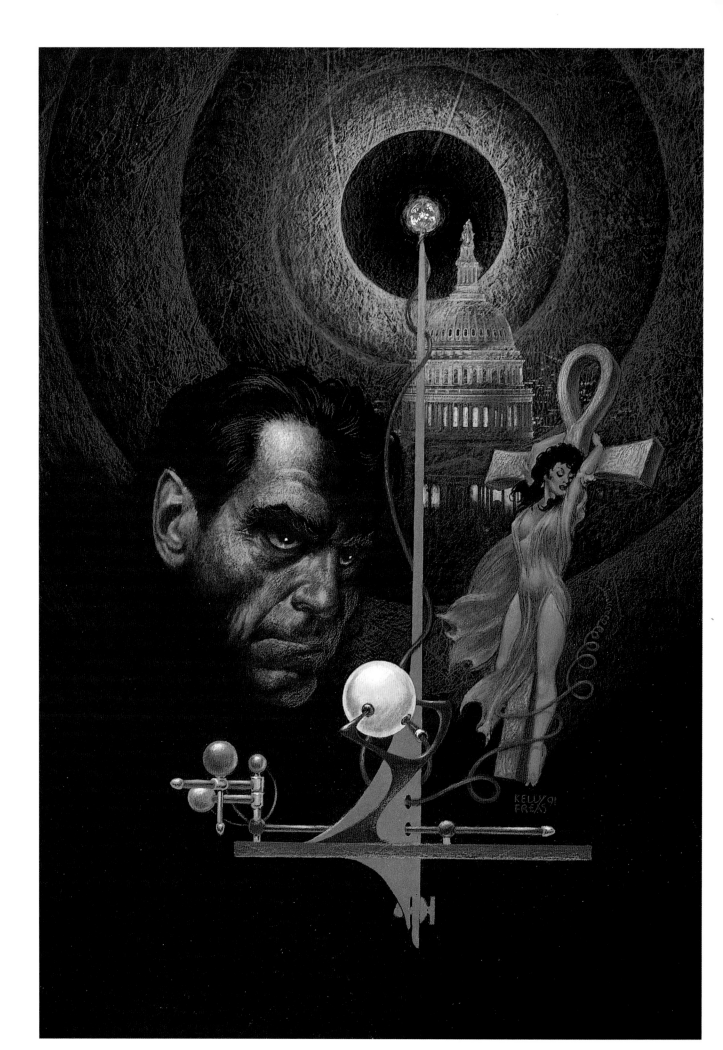

The light and middle-value greyish greens, on the other hand, definitely have a more tranquillizing effect. They were popular during the 1950s and 1960s as institutional colours, which probably explains something about that period. The 'dirty' livid greens, along with purples and blackish reds, are the traditional colours of fear and horror – the colour of bruises, infected wounds, blood clots, poison.

Blues, conversely, are friendly, sociable colours. They tend to make you feel free, open, expansive – like the sky on a fine day. The darker, muted blues and violets make you feel quiet, sombre, maybe even gloomy and dull – like nightfall or an approaching storm. It is interesting that the mood of excited stillness, of mildly menacing mystery, which we associate with the night is so well symbolized by the dark yet very intense colour called 'midnight blue'.

Reds are the most exciting colours of all: exciting, irritating, stimulating, shocking – almost a whole spectrum of varying moods in themselves, which is probably what one should expect from the associations with blood in all its aspects. Reds seem to be a call to action, whether it's the colours of sunrise challenging us to meet the new day or the glowing, brooding reds of sunset warning us to set our defences against the prowlers of the night.

The same range of reds, with varying amounts of black, creates a whole array of browns and russets – the hearth fire, a sense of warmth and homey comfort, baking bread, a nicely broiled steak, homespun cloth . . .

Now, somebody out there is muttering 'Oh, come off it. I don't react to colours like that at all. Brown makes me mad. And yellow makes me want to throw up.'

He's probably right.

There is, by the way, a particularly unpopular colour combination that would guarantee the finest bouquet of prize-wining roses was unsaleable. That is the specific range of creamy and whitish yellows, whites, pinks and reds normally seen together only in extremely deep wounds. Our dislike for the colour scheme would seem to be well justified.

Somebody else is saying, 'I don't pay any attention to colours at all. I'm just not interested: they don't affect me!'

He could be right, too.

The point is, even though there are all sorts of individual variations, statistical laws still apply. The statistics show, among other things, that a full-page advert in colour will outdraw the same page in black and white by a factor of four to one – regardless of the medium in which it's printed or the audience it's aimed at.

The person who says colour doesn't interest him or affect him, that he can take it or leave it alone – this is the person advertisers, publishers, artists and other hustlers just love. Ninety-nine per cent of the time he can be tied in more knots than a Boy Scout craft exhibit. Most of us are reluctant to accept the basic law: the firmer an individual's conviction that he is self-directed and independent of externals, the easier he is to manipulate.

This is an extreme example, of course. But somewhere in the spectrum of possible reactions is your own: *everybody* is affected by colour, with the questionable exception of the totally colour-blind, who are rare. And even if you're colour-blind, in fact, there are visual stimuli to which you'll react – sometimes consciously, usually not. Every shape has certain connotations and emotional associations, and their combinations can become quite subtle. A simple circle implies life, eternity, the sun, 'fruitfulness', the female. A vertical line is a tree, the male, a weapon, defiance, opposition. The horizontal is the horizon, stability, but also cessation, defeat, death. A zigzag suggests mountains, teeth, action, danger. An undulating line likewise suggests movement, but now sinuous – the snake, a wave, a dance – and, by the change of its rhythm, any mood from pleasant excitement to soft serenity.

And, of course, the complex arrangements of shapes and forms, straight and curved, concave and convex, give us hundreds of symbols to which we react in equally complex ways. If there is any doubt in your mind about the strength of the human reaction to the interaction of complex curves, just watch a group of men engaged in an animated intellectual discussion . . . when a pretty girl walks by.

Left:
Bug Jack Barron
Acrylics: 15in x 20in (38cm x 51cm)

The 'Bug' of the title is a verb. Jack Barron is a Washington radio columnist to whose programme listeners are invited to call in so they can give him grief on air. The story is further complicated by the antics of Jack's wife who is, at least figuratively, hung up on an immortality kick.

Frontispiece, novel by Norman Spinrad, Easton Press, 1991

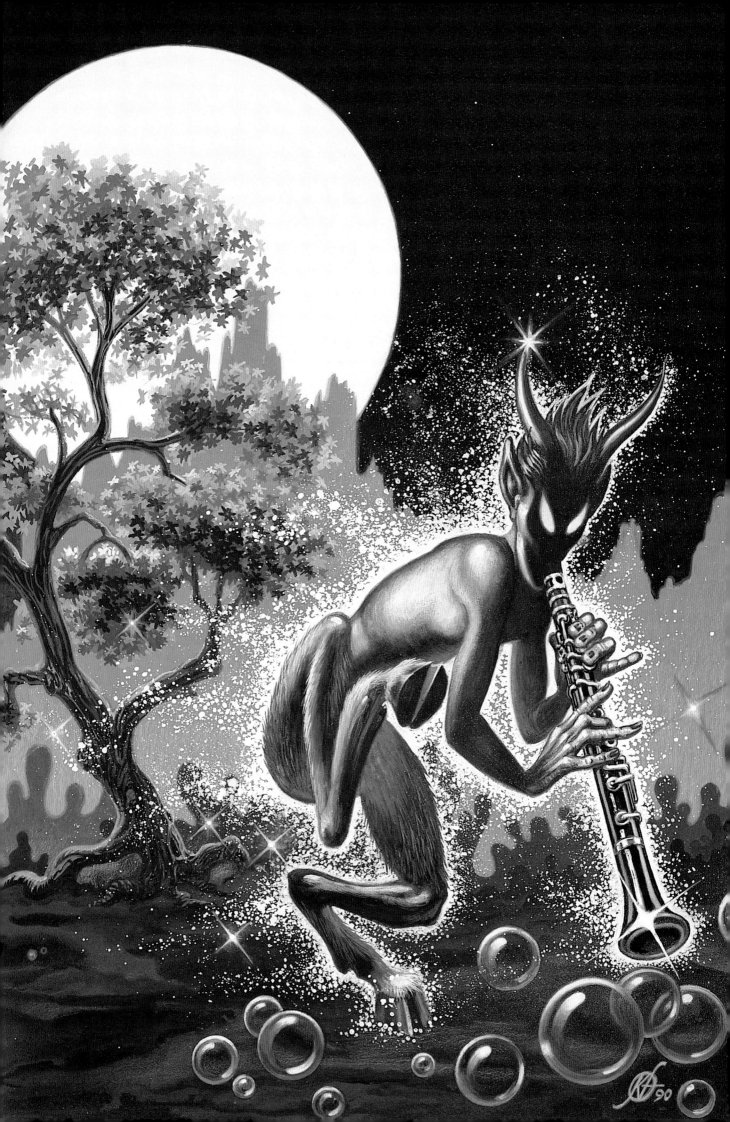

The Way I Work...More or Less

S OME PUBLISHERS prefer to give the artist a short typed paragraph describing the picture wanted, with or without a rough sketch. I don't *refuse* to work that way, but I do discourage it. An editor with many years in the business can obviously pick out good science-fictional situations to be illustrated, but he usually has little visual imagination because he is, by nature and training, verbally oriented. The art director, on the other hand, usually has superb visual sense – but may have little or no understanding of what makes a good science-fiction illustration.

I consider my job – my specific job – is to synthesize the two approaches. As an avid science-fiction reader for several decades I know what the reader is looking for; and as an artist I am constantly searching for new ways to express it in graphic form. To me, this is the *sine qua non* of illustration – to visualize the inexpressible and to express the invisible. And to do it in such a way as to satisfy a reader who has never had the time or opportunity to develop either mode of communication. Everything else is frosting on the cake.

My actual working method tends to vary a great deal according to the story and/or work situation, but it generally follows this pattern:

I receive a manuscript in the mail. (Sometimes I pretend it isn't there for a day or three.) I read it simply for pleasure. My wife does the same. We talk about it; she gives me her ideas, which I may or may not put into sketch form.

I read it again, this time with pen and scratch-pad. I make notes of interesting visual bits – descriptions of scenery, gadgetry, characters, etc. – which might be useful, and perhaps do two or three doodles to indicate possible compositions.

Next, I get out my paints – Shiva NuTempera paints, for this purpose. They work well with pen or brush or airbrush (a very useful tool, when kept under control), dry fast and are sufficiently fluid (i.e., flexible) for very spontaneous and creative painting.

At this stage, my mind is more or less saturated with the story. I can therefore depend on my mind to give me images at least *related* to the story.

My approach to the painting is loose and fluid – lots of water, strong pigment popped by the pointillistic addition of white (for cool areas) or yellow (for warm areas). I may reverse this – no rule is unbreakable. One wants results. I usually work on scraps of mat board or heavy illustration

Left:
Pan, with Clarinet
Acrylics: 15in x 20in (38cm x 51cm)

The second version of my first professional cover sale (which was for the November 1950 issue of *Weird Tales*). The only difference in the two versions is that the Pan in the first version, for reasons of time, did not have a clarinet, but a plain pipe. This one amended the instrument, but it was no easy task. Once the hands were placed properly on the clarinet, everything (elbows, raised hoof, posture, balance, trees, buildings, sky) was interfering with everything else. I had to repaint the entire thing from scratch.

Cover, *Weird Tales*, November 1990

Right:
Pan with Horn
Acrylics: 15in x 20in (38cm x 51cm)

An art school assignment, it became my first nationally published cover.

Cover, *Weird Tales*, November 1950

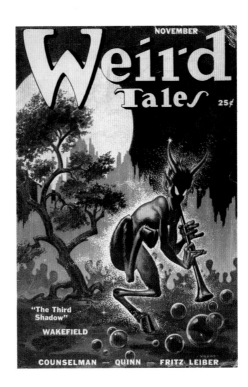

board. The moment any pattern begins to form on the board, it is put aside to dry, and another board is started. Here, incidentally, I am working small: usually 5in x 7in, sometimes the back of a playing card.

When all available level surfaces are occupied by drying studies, I go back to the first picture and carry its development through the second step – figure(s), scenery and gadgets. If a figure develops without scenery or gadgetry I put it aside for future consideration; the same with gadgets and background.

At this stage, one should probably point out to science-fiction fans that there can be many beautiful *pictures* (or paintings) which are *not* science-fiction illustrations. From all this splashing paint around, one can reasonably expect four or five interesting, somewhat (if not totally) abstract paintings which suggest scenes from the story in hand.

Now I go back to the manuscript. Here we have a figure (hero, heroine or alien? somebody else?). I select relevant detail, add, subtract, modify. That shape in the background suggests a wrecked patrol boat . . . I bring it up.

Always point, counterpoint.

Never one idea pushed to its conclusion.

I try to keep my mind as free and fluid as my paint.

Eventually, four or five of these growing compositions become definite illustrations. At this stage I put aside the one I like least and concentrate on those I like best.

Now we are into details: back to the manuscript. I try to make every element fit the story, with due regard for pictorial values. This is the stage at which I go into research. Most of the information should already be in my head – the colour, shape, pattern of a high-energy fuel in a vacuum, for instance; or how to indicate distance in the absence of aerial perspective. But there are endless details I may not have filed mentally: 'The alien looked at him, goatlike eyes blinking slowly.' Goatlike? Have you ever gone eyeball-to-eyeball with a goat? They *are* different – square pupils, even! So I go find a goat, or whatever.

My personal library is larger than that of many a small town, but far from adequate. I often use the public library and all the help it so willingly gives.

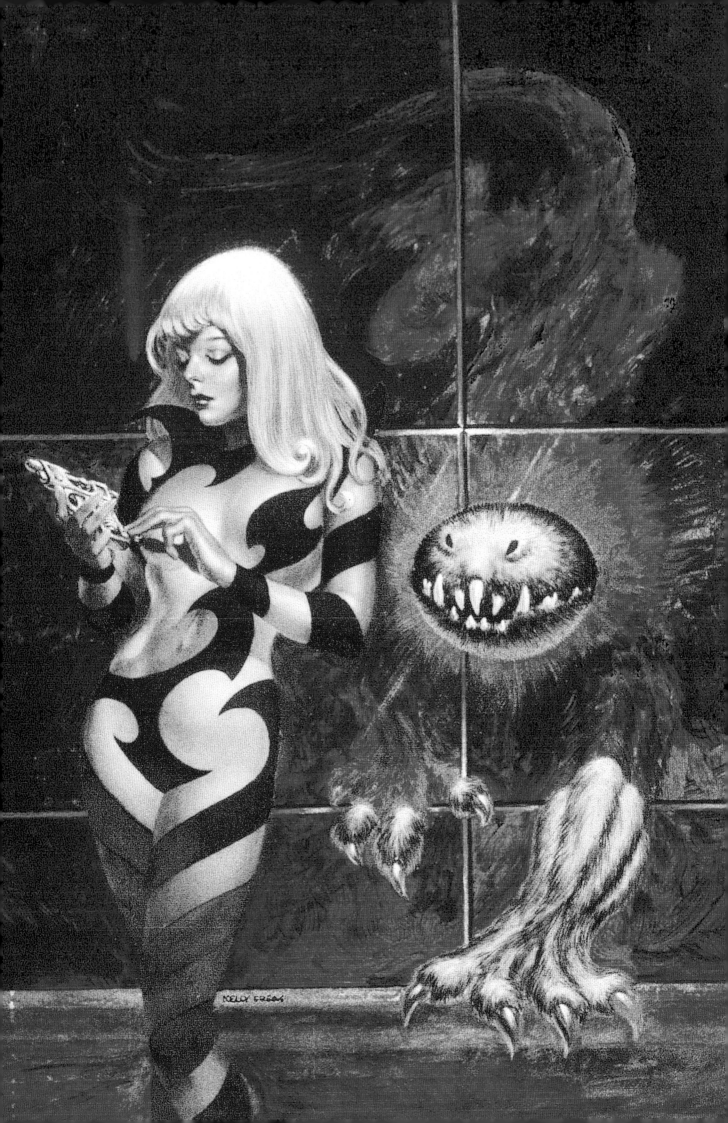

Above:
Scribe
Acrylics: 15in x 20in (38cm x 51cm)

A major collaboration between Laura and myself. Laura had designed the layout and the lettering, and sketched out most of the details, but decided that for the left hand of the main figure she needed a photograph. With Polaroid loaded, cocked and focused on me, she stepped into the studio where I was working at the desk. 'Kelly,' she said, 'did you know that we're out of bourbon?' Shriek! Gesture! *Snap!* Problem solved. Forrest Ackerman liked this one so well he asked me to use the same composition for his upcoming convention poster (see page 61).

Cover, *Marion Zimmer Bradley's Fantasy Magazine*, Autumn 1989, illustrating 'The Book of Souls' by Jason Von Hollander

What photographic material is available on the tracking mechanism of a radio telescope?

How does the inside of a linear accelerator actually look?

What is the readout pattern on the control board of the firing room of a nuclear submarine? Hmph! It was a bit tricky getting an authorization to go for a cruise on one, but I eventually got it. It was a hunter submarine, and I was truly in Kelly heaven. I got all the data I needed, and more, but then, of course, it all turned out to be classified information!

Gradually, several possible illustrations (note: I say 'illustrations' – not just 'pictures') take form. These – usually three or four – are put into neat mats and mailed to the editor or art director. I try to make a point of removing the one I like least, because there seems to be a law that this is the one the client will choose, if allowed. One must retain *some* measure of independence!

The approved study comes back with notes as to any changes the client wants. Not *verbal* notes – the phone is a great gadget, but my memory is as fallible as yours: so I write it down. Writing is still simpler than taping, and afterwards the information is far easier to retrieve.

Our sketch, study or comprehensive (all essentially the same in this context) is now ready for 'rendering' – preparation for the painting by enlarging and transferring the sketch onto the final drawing surface. This stage implies a finished painting two to four times the size of the eventual cover. You can approach it in several ways: by squaring, by projecting, etc.

Most cities have a blueprint shop that can give you bluelines, brownlines or photocopies, each of which modes has its merits. The enlarged print is mounted; you can do this bit yourself with spray adhesive or low-temperature mounting tissue and a flatiron, but it is best done by a professional photographer. His equipment is usually bigger and faster than yours, *and* he can give you two prints just about as cheaply as one, so you have a spare in case you screw things up in the final rendering. Incidentally, I never do things *over*; I do them *again* – if I must. It's faster, easier and better to start from scratch and repaint.

Another method is to enlarge your study with an opaque projector, sometimes called a postcard projector or epidiascope. I do this whenever I'm in a hurry. I simply use the canvas or board as a projection screen and trace the outlines of the picture directly on it. This method can lead you far astray, but it can also lead to considerable spontaneity. Just keep in mind that you are now working on the image approved by the client, so don't make any major changes.

I am often asked, 'How do you make your metal surfaces look so shiny and metallic?' or 'How do you make glass look so fragile and transparent?' My answer is always: 'Look at it. See how the real thing appears – then paint it. As simple as that.' A shiny, formed surface remains a shiny, formed surface whether on an automobile, an airplane or a coffeepot. I observe the real world and extrapolate from that.

The method applies to every subject. Your prospective teachers and educators are of course familiar with the concept of 'affective domain' – those who aren't will, I'm sure, have no trouble finding someone eager to explain the theory in detail. Affective domain, essentially, is the establishment of an atmosphere conducive to learning. In illustration – specifically as applied to paperback covers – it amounts to creating, in a space of 4¼in x 7⅛in, with purely visual means and in a communication period measured in seconds, a sense of contact, the arousal of interest and the assurance that the curiosity aroused will be satisfied by reading the book.

It's a tall order, and it doesn't always come off – especially when the publisher suddenly decides to switch covers. However, we try.

I start from what is familiar to my reader, so as to establish a sense of reality, of conviction; and paint the imaginary in a manner which indicates that it shares the same order of reality.

Cold Cash War
Pen and ink on illustration board: 10in x 15in (25cm x 38cm)

Interior, Analog, August 1977, illustrating the story by Robert Lynn Asprin

For instance, I once had the problem of painting a Christmas tree located in the middle of a moon colony. I solved it by carrying a large mirrored ball (a lawn ornament) to a construction project. The photographs clearly showed the beams and girders of the buildings and the horizon, all reflected in my globe. This provided a perspective grid, with the proper distortion, over which I could design whatever buildings, rockets, gantries, etc., I needed.

If you want to know what a head will look like inside a transparent helmet, put your fist in a fishbowl. A girl in a transparent spacesuit? A plastic model and a roll of plastic wrap will give you lots of ideas. Some of them may even be about space suits.

A spaceship sitting on a planet lit by three suns requires some tabletop work with sand, crumpled paper and cloth, a few bits of sponge and a cocktail shaker (preferably full – to start with). Light it with three spots at different angles and with, say, orange, magenta and cyan filters. Once you have it set up and *seen* what happens with the interacting lights and shadows, it's easy enough to paint – but I say that there isn't an artist alive who could fake it adequately. With a good computer, though . . .

And so to the final painting:

My final paintings are usually done on heavy illustration board, 15in x 20in in size, that being the largest which will pass as carry-on baggage when flying – saves a lot of waiting time at the other end, as well as worry. I use acrylics as my primary medium with the addition or substitution of other media as the subject requires, working first with my colour very thin and fluid, taking advantage of the nature of both paint and board to utilize the natural flowing and blending effects that occur. This stage utilizes largely brushwork, although I may use a rolled-up tissue, a sponge or a crumpled plastic wrap to produce broken effects in very liquid areas.

As work proceeds I use less water, and colour that is more and more opaque, until highlights are done almost by drybrush. Brushes (both flat bristles and sable watercolour brushes), palette knives, sponges, Kleenex, Saran Wrap (clingfilm), reeds and even split-ended sticks come into play for special effects. I use the airbrush a lot, but not routinely: it is extremely useful for laying in a smooth stipple or popping up glowing lights, but an airbrushed surface texture is usually too smooth.

Airbrush is also useful for laying a glaze over a delicate surface; for this purpose I usually mix a very intense aniline dye with acrylic gel and thin it with just sufficient water to make it spray readily.

Working with acrylics has one special advantage: when I am satisfied with one phase of the picture, I can tie it down with plastic spray and work right over it. This allows considerable experimentation, since new work can be wiped off without damage to the work underneath.

Finished, I either varnish with acrylic matte or spray with Krylon clear acrylic coat, then top off with photographers' matte varnish, which gives a very durable non-glare finish. Nowadays I prefer to have the finished painting photographed and send the client one colour transparency (4in x 5in), keeping another for my records. Post being what it is, that's safer. Safer yet, though, is having my wife Laura scan the art on our computer and send the client a TIF file attached to an e-mail. How times have changed.

Permanency is, in commercial work, a decidedly secondary consideration, but I prefer to use quality materials and make my original as permanent as may be practicable. Fortunately acrylics seem to be about as permanent as anything could be, and, if the support finally gives up, the entire paint film can be lifted and transferred to a new base. I know. I've done it.

However, in the interests of permanency for those who collect my originals, I do have one rather sneaky technique. It may be overkill, but it makes me happier.

The high-intensity lights of a one-shot colour camera are murder for most colours – the exposure is as bad as direct sunlight, and for some colours it's even worse. As a matter of course I reinforce my colours to allow for a loss of about 30 per cent in intensity when printed; but I have found that it is also necessary to protect the painting from the bleaching effect of those intense lights. The solution is to intensify the colours selectively by using a fugitive dye in an acrylic medium. During reproduction the lights destroy the dye and the painting returns to what it *should* look like, with the addition of an extra protective coat of hardened polymer. This is simple, effective and permanent.

Right:
Never Mess with a Witch
Acrylics: 15in x 20in (38cm x 51cm)

It might be better to avoid her completely. If we are to believe some of the stories, being liked by one can be as dangerous as being disliked. Unless you enjoy the idea of ending up small, green and spotted, waiting for a magic kiss to break the spell.

Cover, *Weird Tales*, All-Freas Issue, Summer 1990

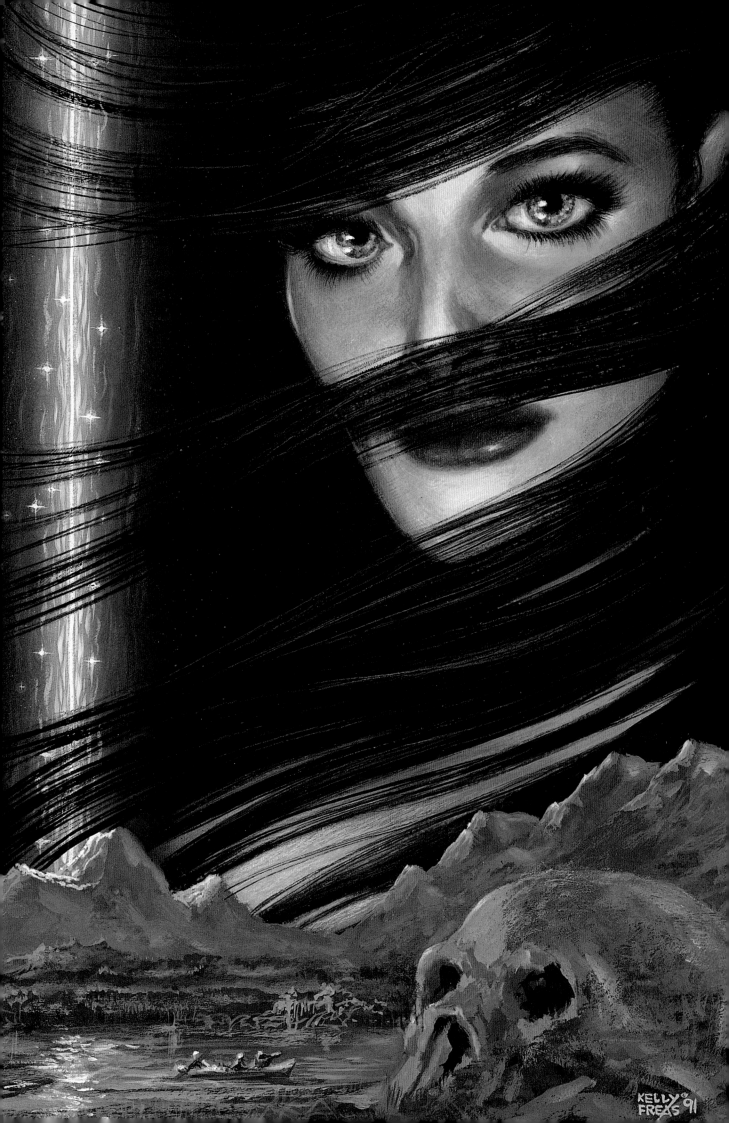

KELLY
FREAS '91

On the Painting of Beautiful Women or Ayesha, She Who Must Be Obeyed

I CAN HARDLY CLAIM to be an expert in the art, but I really ought to be an expert on the subject – which has been my favourite occupation since my first love affair at the age of five. Wonderful, those summer vacations . . .

The real problem is that *all* women are beautiful, in one way or another, and I have never painted or drawn one that I didn't end up loving. Some one way, some another – and a very few totally.

The universal concept of the love goddess who appears to every man as his ideal visualization sounds more complex than it actually is. Current research (dream job!) demonstrates clearly that the most attractive face is the most universal – not necessarily what we call average, but a total composite. By extension we can conclude that 'most beautiful' will eventually resolve itself as meaning 'most human'. And then, of course, we will extend ourselves just a touch further to become acculturated xenophiles. Sorry – XXXenophiles. (Thanks Phil Foglio!)

Over the years, I have discovered a certain quality that keeps turning up in my own pictures of women – which, however different the treatment may be, always become a facet of the same person. This is not quite the same thing as the specialization of style and technique which produces a master illustrator like Andrew Loomis,

Bradshaw Crandall, Charles Dana Gibson, George Petty, Earl Moran and a dozen or so others. Each developed his own particular 'face' and consciously stuck with it. For a portrait painter, which I have always been, such specialization is the kiss of death. The portraitist's problem is to look beyond the immediate appearance to those qualities that present the unique identity *of each subject*, not the trademark of the painter. Even in science fiction, which is both the most specialized of any illustrative mode (except perhaps medical illustration) and the most wide-reaching in subject and approach thereto, the principle still applies. The general or mainstream market actually prefers generic faces 'with which the reader can identify him/herself'. The science-fiction reader, however, wants his characters defined: he doesn't need to identify with them – he is interested primarily in how they solve their own problems. (Science fiction is *not* escapist literature – it is problem-solving and participatory!)

One of my favourite books, from earliest readerhood, has been H. Rider Haggard's *She*. The concept of Ayesha, the most beautiful woman in the world, delighted my heart, challenged my eye

97

Left:
She
Acrylics: 15in x 20in (38cm x 51cm)

An assignment I had always coveted. The dozen or so variations other people had done all showed presumably beautiful nude women bathing in varying amounts of flame. I wanted just a face: my wife's, to be exact.

Frontispiece, novel by H. Rider Haggard, Easton Press, 1992

Right:
Ayesha
Acrylics: 15in x 20in (38cm x 51cm)

Preliminary study for the *She* frontispiece

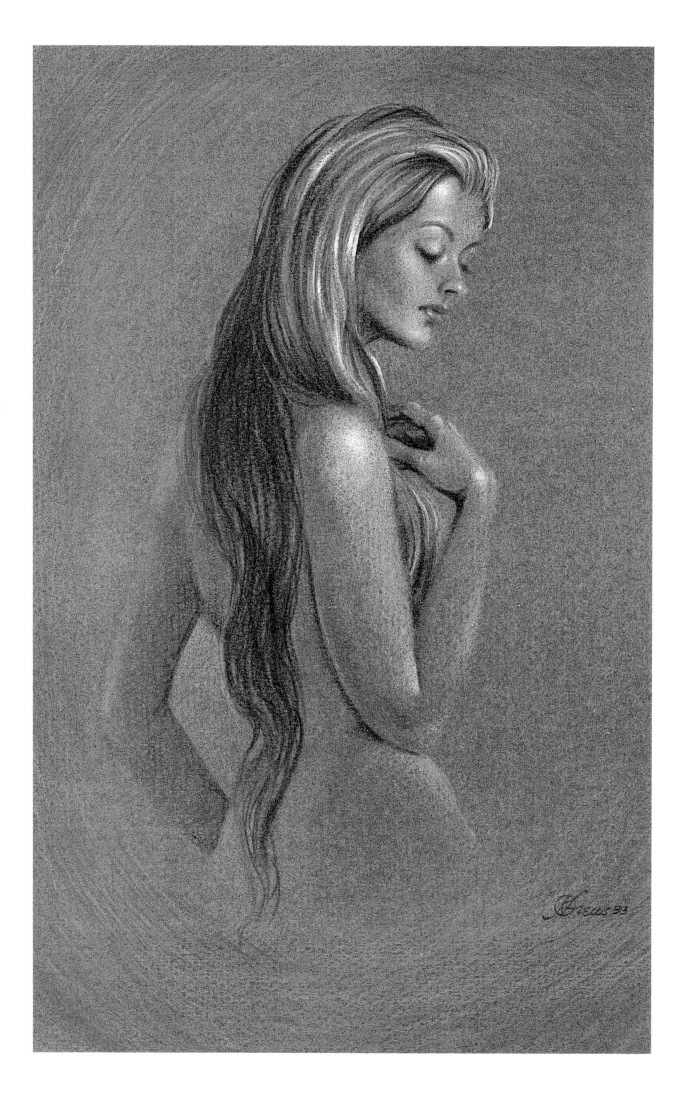

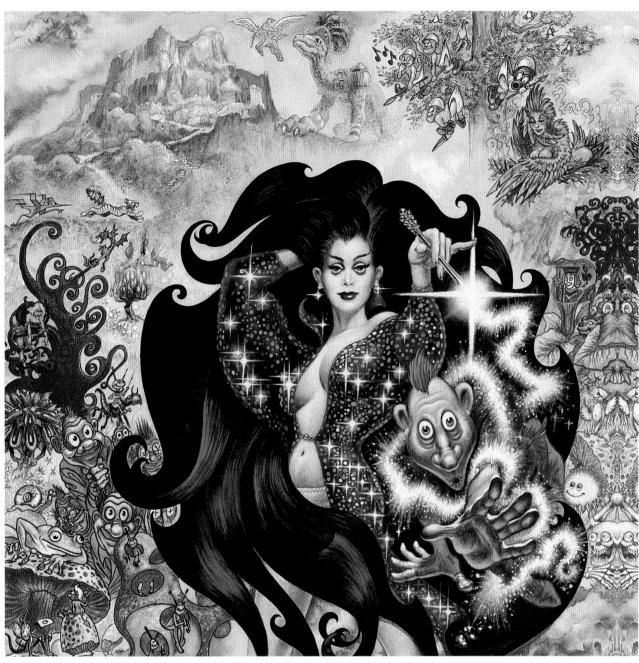

Left:
Blue Nude
Acrylics: 9in x 12in (23cm x 30cm)

This is one of my all-time favourite pictures. Done in coloured pencil, it is only about 9in x 12in, but seems to have a very strong presence!

Unpublished, *c.*1975

Above:
Godiva Goblin
Acrylics: 20in x 20in (51cm x 51cm)

In the Xanthe world, all the goblin women are beautiful and the goblin males are . . . well, you can see for yourself. Godiva is in the process of snaring herself a husband. With his looks, you wonder *why?*

Commissioned for a Xanthe calendar, unpublished, 1990

and thoroughly eluded my slowly increasing skills.
Worse, I was annoyed over the years by the
mundane and pedestrian illustrative expression of
Ayesha as an overendowed pinup girl or as a vapid
Pre-Raphaelite nymph censored by flames.
Capping the insult was the violation of the basic
rule of good illustration: *don't blow the peak scene
with the picture!*

How *do* you present 'the most beautiful
woman in the world' to a modern audience whose
tastes must range from the most statuesque
blonde Viking goddess to the most petite and
piquant African or Asian dreamgirl? *I* knew what
she looked like: she'd been popping up in my
pictures since I was in First Form at high school –
but that was from *my* imagination. How could I use
that image and still provide the general reader with
room for *his* imagination?

Some half-dozen or so studies later I thought I
knew how to handle it. Let the oval face just hint
at a heart-shape. A generic nose that can be read
as a noble arch, or as straight and narrow, or as
tiny and flared – let the observer decide what he's
seeing. The hair should be dark: blonde is more
spectacular, but brunette is more universal, and
black, especially blue-black, conveys an impression
of power definitely in order here.

The mouth was simple enough: essentially an
indefinite, very mobile smear – as you see in
Zuloaga's best portraits of women. The hardest
part would be the eyes: very direct; challenging
without being in any way threatening; vulnerable
but not weak . . . Yipe! They should have a hint
of the Oriental, as should the cheekbones . . .
And they had to have some touch of the alien.
Gold flecks, like Doc Savage's, perhaps? No, not
quite . . . make them opals.

Now we wanted the open directness of the
American girl, the intensity and clarity of the Irish,
the warmth of the African, the mystery of the Asian
and the challenging sparkle of the Latin. (Nothing
to it.) Finish off by blowing the hair forward to
partially hide the features – like a domino.

After 743 sketches, studies and photographs
(I had to quit before the hair-dryer blew
Laura's hair right off her head), I was ready to start
painting . . .

We'll skip that part, except to mention that the
blue laser beam was my concession to the flames.
The swamp, mountains and skull are familiar
enough to Haggard fans to need only a suggestion.
I hated to sacrifice that lovely body, but the eyes
were the focal point.

In sum, if anybody knows the most beautiful
woman the world, Ayesha, She Who Must Be
Obeyed, I'm it.

After all, I married her.

101

A Separate Universe

THE SCIENCE-FICTION FAN truly is a unique phenomenon – not least because no two of them are alike. Whatever stereotype the word 'fan' brings to mind, forget it. Sf fans are unlike any others in the world. The better you get to know them, the less probable they seem. I feel quite certain that they do not, by and large, recognize their own uniqueness, or that of the field they love. It's rather like having a beloved relative living in the house: you only notice them when they're not around. The Sense of Wonder accepted as basic to the genre begins in its devotees.

Now, I know that the majority of you who have bought this book are not science-fiction fans, but readers of science fiction – which is not quite the same thing. (There are fans who never read anything: they discovered science-fiction fandom, and are so busy having fun that they no longer take the time to read.) Yes, you already know how different you are from most of your friends and neighbours ('They all think I'm a little bit weird . . .'), and you find most of their favourite novels and movies rather weak tea at best. You probably have one or two friends who share your interest at least mildly; but you may never have encountered a fanzine and, if you have ever heard about a science-fiction convention, you assume it must be mostly for writers and editors. Besides, conventions always seem to be held so far away.

Let me fill you in a little. (Fans, bear with me. You are already so steeped in the mystique of science fiction that you don't begin to know how special you are.) This fill-in may change your life – and certainly it can open up to you a whole world of warmth, love, companionship and excitement, the likes of which you have scarcely imagined.

Fandom is not an organization. There are even those fans who insist that the very word 'organization' is unknown to it. It is, in fact, an entity. It seems to have a life of its own, expanding and contracting and sending out pseudopods into every specialized area of interest imaginable. To spread the metaphor a little thinner, it ingests everything in sight, but apparently never excretes, which is why most fannish domiciles gradually sink into the ground from the sheer weight of books

Left:
He Says He's from WHERE?
Acrylics: 15in x 20in (38cm x 51cm)

The crew of the spacecraft is not frightened of the alien, however ugly he may be. After all, it takes all kinds to run a spaceship, and they are used to weird types. But they're astonished that he has actually come all the way out here in his own ship (note that the latter seems to be government surplus). And from *that* puny planet . . . they wrote it off as useless 500 years ago.

Cover, *Science Fiction Writers of America Membership Directory*, 1993–4; also used as Artist Guest of Honour cover for programme book, Balticon 31, Baltimore, Maryland, March 1997

Right:
The Listeners
Acrylics: 15in x 20in (38cm x 51cm)

When the first communication comes in from outer space, it sparks a veritable war between the generations. The younger scientist wants to go public, and the religious elders insist on secrecy. The aerial on the ground is the present one in Arecibo, Puerto Rico. The star is the Big Ear, a powerful receiver in orbit, which has picked up the alien message.

Frontispiece, novel by James Gunn, Easton Press, 1991

103

and unanswered letters. Its natural symbol might be the packrat.

Fandom is composed of people from all over the world, of every age, from every walk of life, income bracket, social stratum, profession and interest. You even encounter the occasional scientist.

You'll meet Regency buffs, computer freaks, glass-blowers and rugmakers. There will be costume-designers, weapons devotees, classical musicians, sculptors, schoolteachers, librarians, mechanics and karate experts. And all of them bonded together, loosely but definitely, by the magic glue of science fiction.

These devotees seem to spend every available dime doing something related to the field. Aspiring authors and artists write stories and draw pictures which they publish in fanzines. The latter they mostly trade with each other, but sometimes actually sell. If they should miraculously turn a profit on an issue, you can bet that the surplus will all go towards better paper or a colour cover or more pages for the next issue. The magazines vary considerably in quality, from very close to professional (occasionally superior) to almost painfully amateur. But their publishers learn from them; some to go on as professional editors and publishers and others to become writers and artists. Many of the pros in the field have cut their teeth on these amateur efforts: there are few better ways to learn a business, because the feedback is fast and loud.

The fanzines are, however, only the beginning.

A major fan activity is the putting on of conventions. There is a convention somewhere in the USA every week of the year, with the possible exception of Christmas week. Some are tiny local ones with only 100 or so attendees; while others attract up to 10,000 or more. The World Science-Fiction Convention, held annually over Labor Day weekend in a different part of the USA (or, around every fourth year, overseas), is the high point of the year.

Part of the excitement of the 'World Con' or 'Worldcon' comes in the award ceremonies, at which fans and professionals alike are recognized for the quality of their work during the preceding year. Perhaps an equally important event is the Masquerade Contest – a transgalactic Mardi Gras, Halloween and Carnival all combined and put under one roof. There are aliens of all shapes and sizes, some from books and some original to the costumer. There are beautiful belly dancers in filmy draperies and slave persons in chains and animal hides; there are imperial storm troopers and barbarian pirates and warrior maidens . . . a gloriously colourful and always exciting display of superb craftsmanship and imagination.

Many people wear costumes for the whole weekend, whether or not they enter the competition. One of my favourite recollections involves a near confrontation at a relatively small regional convention.

A seven-foot-tall green man wearing chartreuse scales, a long tail draped gracefully over one arm, feathery pink antennae and not much else stepped out of the elevator into the hotel lobby – and nearly trampled a diminutive bit of lavender and old lace who had just checked in. Her hand flew to her mouth and she gave an audible gulp as the creature rumbled 'I beg your pardon' and vanished into the men's room.

'Oh, my!' she gasped. 'Oh, *my*!' And she scuttled back to the reception desk. I couldn't hear what she was saying, but the way she kept pointing indicated the nature of the discussion. Then she nodded and moved back to the elevator, keeping a wary eye on the door marked 'Gentlemen' until the lift arrived. When she had gone I asked the room clerk what *that* had all been about.

With an indulgent smile, the clerk replied, 'Oh, nothing really. She just wanted to be sure there was no big green man on *her* floor.'

Then there was the time we were booked into an hotel with a convention of bikers . . . it was debatable which group was the more uneasy – but there was a noticeable absence of fraternization. Another rare experience came during a similar sharing of convention facilities with several hundred dedicated barbershop harmonizers. Listening to 'They Call the Wind Maria' rendered simultaneously by not just one but a number of well-oiled quartets at 4:00am is a memory to be treasured.

Folksongs are a vital part of science-fiction conventions, but folksongs with a difference: 'filksongs', as they're called. Virtually all the songs are about space – and the races that inhabit it. The tune may be entirely new, or it may be as familiar as 'Barbara Allen' or 'The Golden Vanity', but the words are likely to fill you with nostalgia for the good old days of 1000 years hence, on starworlds yet to be discovered. Every night the space-minstrels gather with their guitars, an audience quickly forms – and the next thing you know it's

Armada
Acrylics: 15in x 20in (38cm x 51cm)

The flagship is designed not to hide but to impress with its size, luxury and armament. Its attendant cruisers and destroyers, to all appearances harmless, featureless globes, are actually fully equipped fighting ships.

Cover, *Amazing Stories*, August 1991

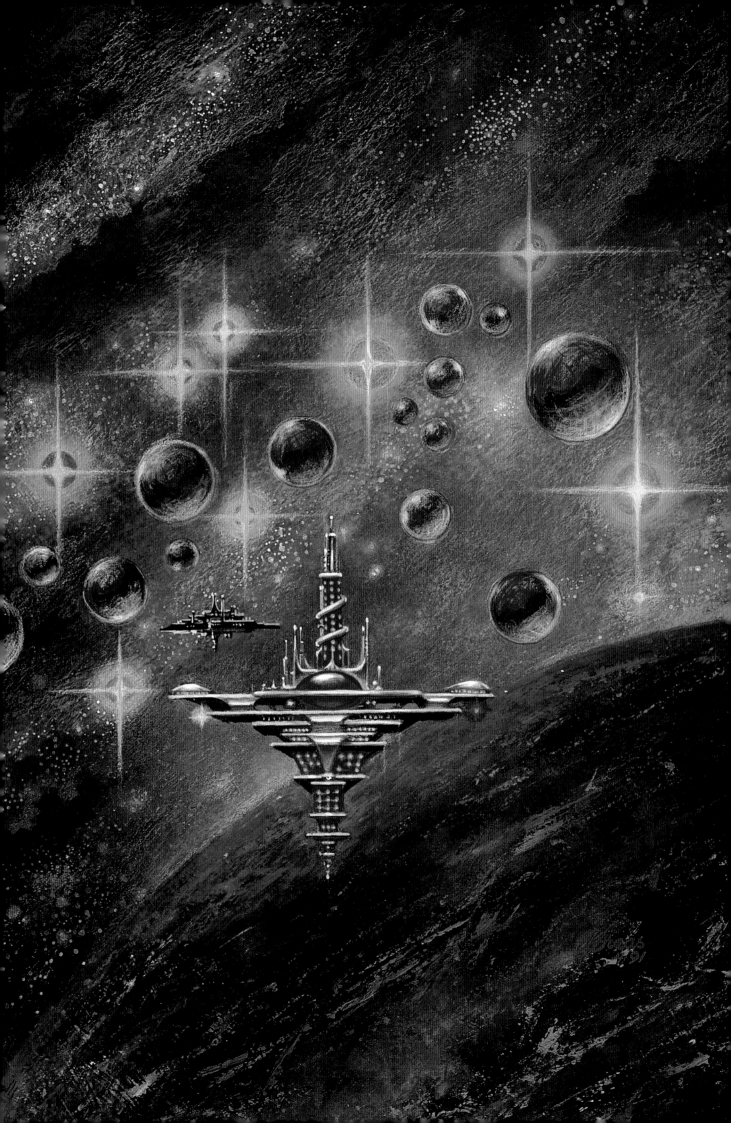

Left:
The Martians
Acrylics: 15in x 20in (38cm x 51cm)

The first generation of Martians came in space suits. The fourth wore breathing masks. The tenth breathes the air, what little there is of it. My version suggests that they also grow taller (because of lesser gravity) and thinner – from hunger.

Frontispiece, novel by Kim Stanley Robinson, Easton Press, 2000

Above:
Hand of God – Divine Fortune
Acrylics: 20in x 15in (51cm x 38cm)

One of several treatments of *Dune* for various publications. All, naturally, emphasize the significance of water on a desert planet.

Trading card for *Dune*, Last Unicorn Games, 1997

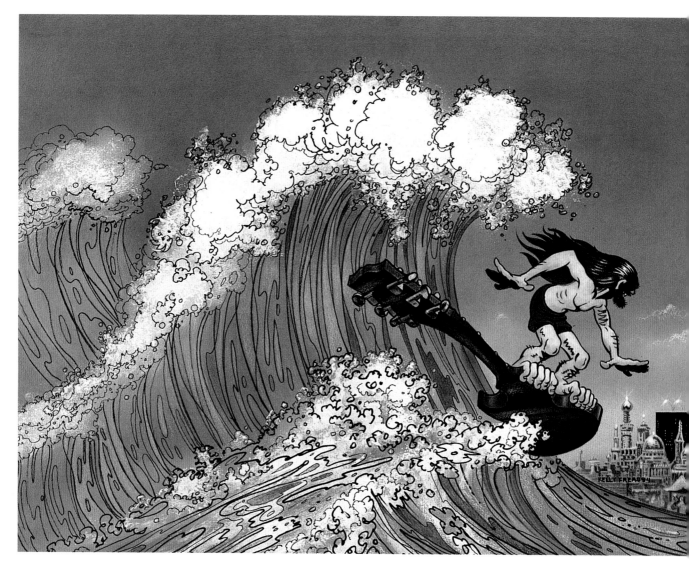

Above:
Surfing to Mecca
Acrylics: 20in x 15in (51cm x 38cm)

Done for an album cover, named after the lead track. Finding a concept to match the title could have been a stumper. Sooooo . . . if you're going to do the impossible, do it *with the impossible – on a guitar hangin' ten*!

Cover, album by Celtic rock band Tempest, Firebird Music, 1994

four hours later, and a panel you want to attend is scheduled for 9:00am that morning . . .

The professionals on the panels, or with their separate talks, slide shows, demonstrations and rap sessions, are more than willing to teach or entertain. And the non-professional can be sure of being stimulated by inside stories, anecdotes, arguments and occasional virtuoso singing performances from masters of the art such as Robert Silverberg or Harlan Ellison; even the late Dr Isaac Asimov was in fine voice on occasion. Science-fiction pros are – with perhaps one predictable but more expensive exception – the most approachable pros in the world, and are, like the fans, willing and eager to share their interests with you.

One of the most important functions at any science-fiction convention, large or small, is the dealers' room. Naturally there are books – old books, new books, piles and boxes and stacks of books. There are guns that flash and sizzle, pendants, pins and bracelets that blink and beep, and cuddly little alien creatures that buzz and rub you when you touch them. You can buy a dragon to curl around your neck or a poniard to wear in your boot. There are the creators of all kinds of beautiful and imaginative pottery and ceramics, superb glass-blowers who will make the most intricate and lovely decorative glass while you watch, wood-carvers, metal-workers, jewellers, artists, poets and minstrels.

This huckster room is one of my favourite places. Laura is well aware of this – and she wisely takes away my wallet before allowing me loose. Be warned. There is always something irresistible, in any price range you can imagine.

Not to be missed is the art show, big or small. Every year new artists try their hand at science fiction and fantasy, and this is the place where they can rub elbows – or lock horns – with peers and elders, at a negligible fee or none at all. Nor are

editors and art directors unaware of the shows: they look them over carefully, with an eye out for new talent.

There is virtually no crime of any sort at science-fiction conventions: even vandalism (that bane of all convention hotels) is almost unheard of. Weapons are very much in evidence, but strictly for display as part of a costume. Even the children are well behaved, probably because they're too busy to get into trouble.

You might not expect a group so far out as science-fiction fans to be much concerned with children. You would be wrong. Children are not only safe, they are cherished. 'The big ones look after the little ones, and the boys look after the girls, and the girls, of course, look after everybody', to paraphrase Charlotte Armstrong. And many of the younger fans simply hole up in the movie room for as long as they can stay awake. What greater delight than a weekend orgy of science-fiction movies? Twenty-four hours a day sometimes: old ones, new ones, previews and many you'd never find anywhere else.

It is hard not to overemphasize the convention aspect of science fiction. You see, to most science-fiction fans, conventions are like family reunions. Here they find people they can talk to, people who speak the same language, and people whose breadth of interests – whose art and scope – enlarges their own. Here, too, everyone can relax and enjoy, without being looked at as if they had just dropped in from Arcturus.

In can be startling to hear a dignified-looking septuagenarian addressed as 'Joe' by a sub-adolescent – until you realize they are discussing the relevance of games theory to the battle tactics

Shall Inherit
Pen and ink on two-ply board: 9in x 12in (23cm x 30cm)

Publication history lost

of the Galactic Patrol in the works of E.E. Smith PhD and are totally unaware of any distinction based on mere age.

In all modesty, this is a 'pool of intelligence far above the average. Not necessarily intellectual, I hasten to add!' Fans also tend to be quite down-to-earth. Frequently loners, they are often wise beyond their years, and, equally often, youthful despite them. Many highly intelligent and talented youngsters take to science fiction, and it gives them an arena in which they can experience and learn over a broad area of activity, without fear, but with enjoyment and excitement.

Naturally, even science fiction is not all sweetness and light. There is never a Worldcon without a plethora of second-guessing and simple post-mortem grousing about the organization. But think of the management problem, for example. Here are fans from all over creation working together to make this thing go. Cooperation is the watchword, because the logistics of the operation alone are daunting (recording, quartering, moving, feeding and controlling 5000 or more isn't easy, especially without any hint of regimentation – you just *don't* regiment science-fiction fans). Remember these are science-fiction amateurs, all working in their spare time, and doing it – Heaven help them – for *fun*. There is no way that putting on a major convention can be less than a major learning experience. Income, disbursements, contracts, fulfilments, security, liaison, publicity, advertising – BOOM! Why it doesn't blow up every other time I can't imagine. But not only do convention organizers solve all the problems with admirable aplomb and considerable cool – they're always ready to do it again next year.

You can see why I think that science-fiction fans are something to be enjoyed and treasured – and, when next you happen to find yourself near a convention, stop in and enjoy. Your life may never be the same again.

About Kelly and Laura Freas

Frank Kelly Freas

A *Who's Who* biographee, Frank Kelly Freas is recognized as the most prolific and popular science-fiction artist in the genre's history. He was the first person to notch up ten Hugo awards (he has been nominated 20 times), and he has received an equal number of other national and international art and graphics awards. In addition to his work in science fiction, he was the cover artist for *MAD* magazine for several years. He is an official NASA mission artist, and his space posters hang in the Smithsonian; his commissioned design for the Skylab I crew patch became the focus of a article and cover painting for *Analog*. His original paintings hang in museum, university and private collections. He has published three earlier volumes of his pictures and was the first science-fiction artist to make his pictures available as prints. One of his most ambitious assignments has been his commission from the Franciscans to create all 500 portraits for their *Book of Saints*.

His career extends from pulp-era magazines such as *Astounding* and *Planet Stories* to modern science-fiction books, magazines, games and motion pictures, as well as conceptual medical illustration and advertising. He and Laura jointly won the Association of Science Fiction and Fantasy Artists' 1990 Chesley Award for their painting *Scribe* (see page 92), judged Best Magazine Cover of the Year. In 1991 Kelly Freas was inducted into the National Hall of Fame of the National Association of Trade and Technical Schools, and in the same year he received the Readers' Poll Award from *Analog* for Best Cover of the Year. He was the recipient of the L. Ron Hubbard Lifetime Achievement Award in 1999, and was for seven years the Coordinating Judge of the L. Ron Hubbard Illustrators of the Future Contest, of which today he remains a quarterly judge. This year he became a Fellow in the International Association of Astronomical Artists.

Laura Brodian Freas

Laura Brodian Freas, a Doctor of Music Education, began her professional career as Interim Director of the Indiana Arts Commission, before becoming engineer, host and producer of classical-music radio programmes at WFIU-FM, Bloomington, Indiana. She moved on to KQED-FM (San Francisco) and then KUSC-FM (Los Angeles), where she hosted the nationally syndicated classical-music programme *Music Through the Night* for Public Radio International. She has also hosted Delta Airlines' in-flight classical-music programme *Delta Symphony*. More recently she has been morning drive host on all-classical KKHI (San Francisco), and she has also been heard on KKGO (Los Angeles) and XBACH (San Diego).

An illustrator in her own right, Laura runs Kelly Freas Studios, where she is in charge of marketing, scheduling, merchandising, contracts, finance and publicity. She also built Kelly's website. Her first nationally published illustrations appeared in (among others) *Weird Tales*, *Analog* and *Marion Zimmer Bradley's Fantasy Magazine*, and in special editions for The Easton Press. A co-recipient of ASFA's Chesley Award in 1990, she has since been nominated again three times.

A former Director-at-Large of the Costumers Guild West, Laura founded the (San Francisco) Bay Area English Regency Society and for two years was president of the Southern California Early Music Society. She served two terms as Western Regional Director of the Association of Science Fiction and Fantasy Artists, and is a quarterly judge for the L. Ron Hubbard Illustrators of the Future Contest.

Open Space #1
Acrylics: 15in x 20in (38cm x 51cm)

One of our earliest collaborations. Laura did the foreground (muttering, 'Buildings. Crowds of people. Trash piles . . . why do I always get the scutwork?') while I did the central figure. Sometimes it pays to be the boss of the operation.

Cover, *Open Space #1*, Marvel Graphics, mid-December 1989; also used as Artist Guest of Honour cover for programme book, CoastCon XX, Biloxi, Mississippi, March 1997

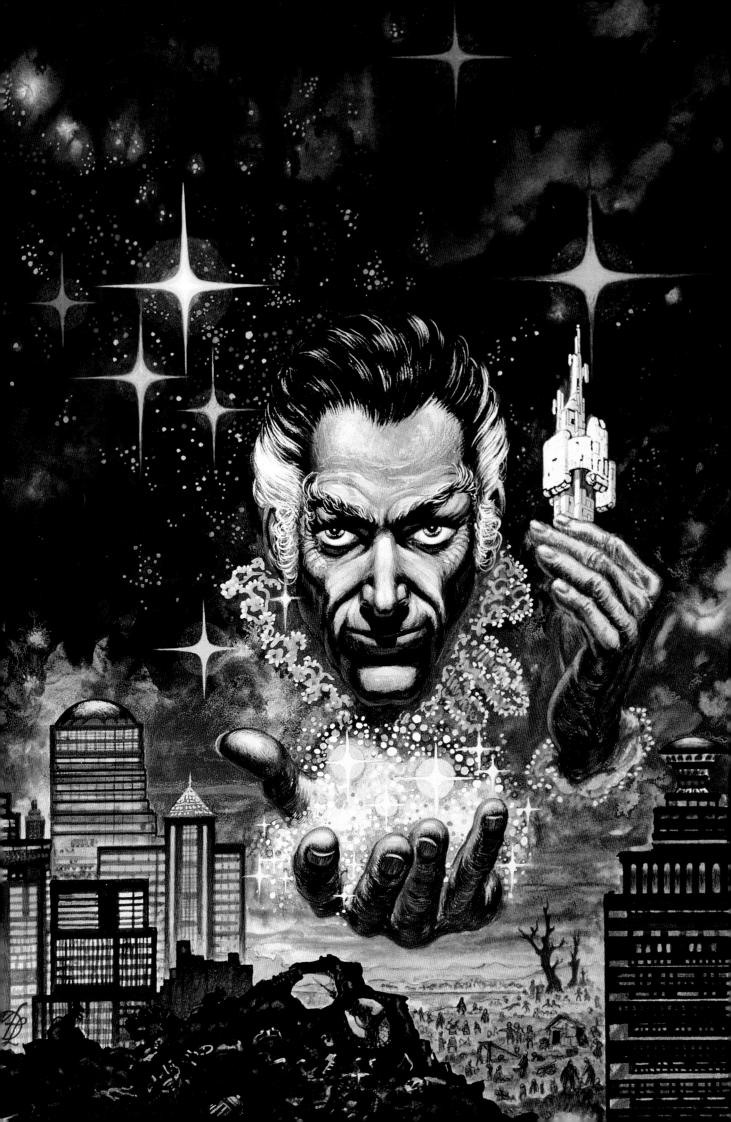

Index of Works

Albino 100
Alfie and the Little Green Man 59
Animal Farm 70
Aquila: The Final Conflict 77
Armada 105
Arzach 34
Ayesha 97

Bar Exam 48–9
Blue Nude 98
Bug Jack Barron 86

Campbell's World 40
Cloud's Rider 82
Cold Cash War 93
Cold Crash 74

Deadline Job: Teamwork – That's What Does It 12
Dick Scobie 11
Dinosaur Beach 50
Door into Summer, The 17
Dying Inside 53

End of Summer, The 27

*Famous Monsters of Filmland World
 Convention Poster* 61
Flying Tiger 68

Genetic Profile 56
Godiva Goblin 99
Gulf Between, The 76

Hand of God – Divine Fortune 107
Haut-Clare 37
Have Space Suit – Will Travel 73
Hawk Among the Sparrows 20
Hawks of Arcturus, The 75
He Says He's from WHERE? 102
Heart of the Enemy, The 79

Incoming 19
Intergalactic Hockey 64–5

Jerry's Catalog, The 10
John W. Campbell, Ed. 38
Jupiter Station 85

Krishna 83

L. Sprague de Camp 43
Left Hand of Darkness, The 57
Lensman, The 29
Lion Game (Dangerous Game), The 91
Listeners, The 103
Live Coward 16

Maelstrom's Eye, The 28
Marauders of Gor 18

Martians, The 106
Matter's End 30
Medea 80–81
Men and Axe 41
Mister Justice 69
Monoclonal Antibodies I 54–5

Never Mess with a Witch 95
Nineteen Eighty-four 71

Open Space #1 111
Operation Luna 35

Pan, with Clarinet 88
Pan with Horn 89
Pandora's Planet 21
Plugged-In Cyber-Girl 5
Pulsar 32–3

Quaddie 62
Queen of Angels 36

Red Tape War, The 66
Research Station 22
Riot 101
Robert A. Heinlein 42
Rosemary's Baby 63

Sam Boone's Appeal to Common Scents 51
Sam Moskowitz 46
Scribe 92
Self-Portrait 7
Serenissima 84
Shall Inherit 109
She 96
Side Bet 13
Skies Discrowned, The 6
Skylab Painting 44
Skylab Patch 45
Slan 84
So Be Good for Goodness' Sake 39
Space Artist 15
Star Trek Annual 60
Super Hugos, The 14
Surfing to Mecca 108

Telzey Toy, The 90
Thinking Beyond the Edge 2
Time Keeper 47
Transition 3

Victorian Space Girl 67
Vincent Price 58

We Make Giant Lenses 23
Wishing Season, The 72
World Menders, The 26

Yes, But He WON'T Go! 24–5

Frank Kelly Freas